HARROGATE

THROUGH TIME

Paul Chrystal
& Simon Crossley

AMBERLEY PUBLISHING

Acknowledgements

Thanks go to Sarah McKee, Community Projects Officer, Bettys & Taylors of Harrogate, for the old photographs on pages 56–63; Mr V. Johnson for permission to use the old images of Hotel Majestic on pages 37–39; Lynn Mee and staff at the Turkish Baths for allowing access and photography; Joy Power at Harrogate Ladies' College for the photographs on pages 91–93; Robert Ogden of Ogden of Harrogate Ltd for the pictures on pages 66–67 and allowing me to take the new photographs; Sally Hall of Yorkshire Agricultural Society for the photographs on pages 94–96; Emma Tugden at Harrogate Theatre; Andrew Lane at the Royal Hall, Harrogate International Centre; Ros Watson and staff at the Royal Pump Room Museum; the staff at the Royal Baths Chinese Restaurant. Simon Crossley has, as usual, done a splendid and crucial job processing and managing the illustrations.

Paul Chrystal and Mark Sunderland are authors of the following titles in the *Through Time* series, published in 2010: *Knaresborough*; *North York Moors*; *Tadcaster*; *Villages Around York*; *Richmond & Swaledale*; *Northallerton*.

Paul Chrystal and Simon Crossley are authors of the following titles in the series, to be published in 2011: *Hartlepool*; *Vale of York*; *Redcar, Marske & Saltburn*; *York: Industries & Business*; *York: Places of Learning & Worship*; *Towns and Villages Around York*; *Pocklington and Surrounding Villages*.

Other books by Paul Chrystal: *A Children's History of Harrogate & Knaresborough*, 2010; *An A–Z of Knaresborough History*, Revised Edn, 2011.

Unless acknowledged otherwise, all contemporary photography is by Paul Chrystal. To see more of Simon Crossley's work, go to www.iconsoncanvas.com

For the town that is famous for its springs

First published 2011

Amberley Publishing
The Hill, Stroud
Gloucestershire, GL5 4EP

www.amberley-books.com

Copyright © Paul Chrystal & Simon Crossley, 2011

The right of Paul Chrystal & Simon Crossley to be identified as the Authors of this work has been asserted in accordance with the Copyrights, Designs and Patents Act 1988.

ISBN 978 1 4456 0204 2

British Library Cataloguing in Publication Data.
A catalogue record for this book is available from the British Library.

Typeset in 9.5pt on 12pt Celeste.
Typesetting by Amberley Publishing.
Printed in the UK.

Introduction

Harrogate is, by any measure, a fine and elegant town. The buildings that stand as testimony of its heritage as a leading European spa town, its grand hotels, the abundance of flowers every spring, the magnificent Stray, the equally magnificent Valley Gardens, 'institutions' like Bettys and Ogden's – all of these combine to produce a place that exudes style and breathes history, a place where it is simply good to be. Not that this has made it superior or arrogant in any way – far from it. The town has always enjoyed a reputation for being decidedly more workmanlike and informal than other spa towns such as Bath or Cheltenham.

To a greater or lesser extent, all of this is revealed in *Harrogate Through Time*. By juxtaposing old and new photographs, the book provides an intriguing glimpse of how Harrogate was, and how it is today. Obviously, the scope of the book is determined by the images that are available to the author and, for that reason, the pictures and captions provide a selective rather than a continuous history of the town. Nevertheless, many of the important facts are here, and the reader will finish the book with a good understanding of Harrogate's development from two distinct villages to a pre-eminent spa town, offering more variety in terms of treatments and waters than anywhere else in the world.

A 1930s guide to Harrogate summed up the town as 'the Mecca of the Ailing, the Playground of the Robust' and in that motto lies the essence of the place. The Tewit and St John's Wells, the Royal Pump Room, the Royal Baths and the Stray give us the therapeutic aspect; the Royal Hall, Hotel Majestic and other hotels, Winter Gardens and Harrogate Theatre provide the accommodation and night life. The marvellous conservation and restoration work that has kept history vibrant and alive complements this, as you can see from the contemporary pictures of the Royal Hall, Harrogate Theatre and the Royal Baths.

Times change: after the Second World War, the days of the spa were numbered, forcing Harrogate to reinvent itself. Making full use of the facilities already in place, it established itself as one of the country's leading conference and exhibition centres, and as a major concert venue in the North. Along the way it won a reputation as a truly floral town, and its function as home to the Great Yorkshire Show goes from strength to strength. Again, much of this change and progress is depicted and described here.

None of this, of course, would have happened without people, and it is no surprise then that a wide range of residents and visitors

populate the book: from William Slingsby and his discovery of the first spring, to Betty Lupton and the local developers of the various wells and waters; the medical scientists who analysed and promoted them and the patients who took the cure. A rich cast of characters made the place what it is and what it was. The list of visitors is endless, with Defoe, Byron, Smollet, Dickens and Agatha Christie making cameo appearances, along with Elgar, Britten, Parry, Bax and the Beatles, to name but a few. Add to this a walking Debrett's of British aristocracy and European royalty, and the book comes alive with literary, musical and historical anecdotes matched only by the very real stories that local firms like Bettys & Taylors, Farrah's and Ogden's live on to tell us.

Paul Chrystal, June 2011

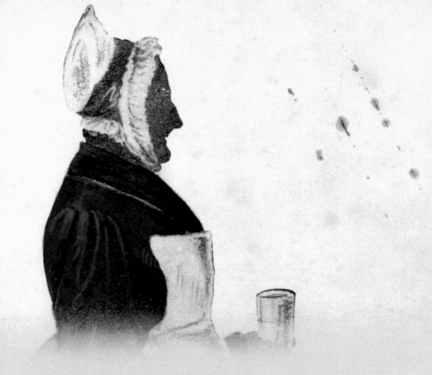

CHAPTER 1

Harrogate, the Spa

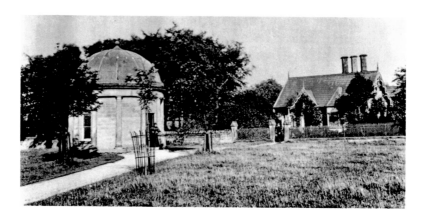

The Tewit Well

William Slingsby's discovery of the strange, rusty-looking waters of the Iron Spring, or Tuewhit – later Tewit – Well in 1571 marked the genesis of Harrogate as a world-famous spa town. Dr Edmund Deane, a prominent York physician, in his 1626 work *Spadacrene Anglica* or *The English Spaw Fountaine*, tells us that Slingsby brought the newfound asset to the attention of Queen Elizabeth's physician, Dr Timothy Bright. Bright, on drinking the water, 'found it in all things to agree with those at the Spaw' – namely, the two famous medicinal springs of Sauvenière and Pouhon at Spa in Belgium, which happened at the time to be a den of Catholicism that the English Crown was trying to deter its subjects from visiting. Finding a spa in Harrogate (the first English town to be thus named) was literally a godsend, and from then on Harrogate's reputation was assured. Another link, albeit tenuous, between Spa and Harrogate is that Swan Hotel refugee Agatha Christie's fictional detective Hercule Poirot was born in Spa. The Well inherited the 1808 Tuscan-columned temple, originally at the Royal Pump Room and designed by Thomas Chippendale; it was closed in 1971 – 400 years after its opening.

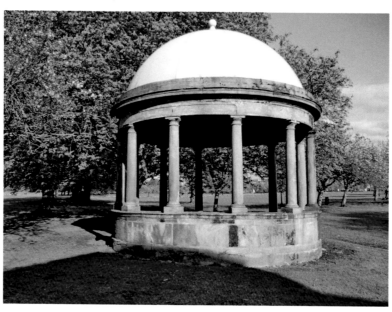

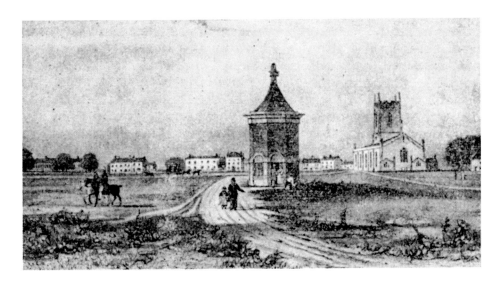

St John's Well

St John's, or the 'Sweet Spaw', was discovered in 1631 by Michael Stanhope and was soon joined by a 'necessary house' (toilets), thus providing a very early example of a roadside service station. The medical profession generally, and Stanhope in particular in his 1632 *Cures Without Care*, promoted the benefits of the waters, and claims grew that they helped in the treatment of indigestion, flatulence, 'hysterical affections' and alcoholism. For many years it was the most popular of Harrogate's chalybeate wells. The first pump room here was built in 1788 by local Alexander Wedderburn. Not everyone, though, was happy: this from Dr Short in his 1740 *History of Mineral Waters* – 'the rendezvous of wantonness and not seldom mad frolics ... luxury, intemperance, unseasonable hours, idleness, gratification of taste are becoming so fashionable ... now it's become so chargeable.' Whether he was genuinely concerned that his colleagues' good work was being undone by the apparent decadence, or whether he was just moaning about the prices, remains unclear. The well closed in 1973.

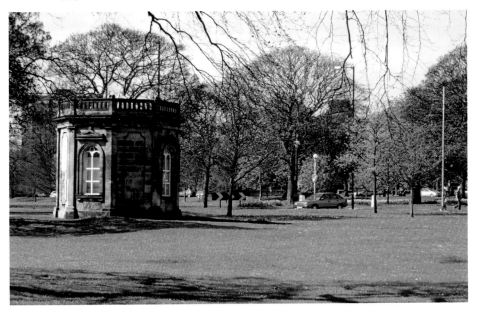

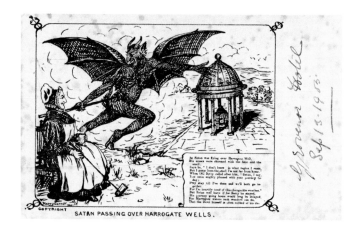

SATAN PASSING OVER HARROGATE WELLS.

The Devil Comes to Harrogate

The satanic verses from this 1905 card read:

> As Satan was flying over Harrogate Well,
> His senses were charmed with the heat and the smell,
> Says he "I don't know in what region I roam
> But I guess from the smell I'm not far from home."
> When Old Betty called after him "Satan I say,
> You were might pleased with your journey today;
> Pray stay till I've done and we'll both go together.
> For I'm heartily tired of this changeable weather".
> But Satan well knew if for Betty he stayed ,
> His journey going home would be delayed,
> For Harrogate waters such wonders can do
> That the Devil himself is often robbed of his due.

The modern picture shows a display of early local transport in the Royal Pump Room Museum today. The bath chair is nineteenth century, but was in use until 1931 when the owner, Mr H. Robinson, retired. Bath chairs had largely replaced sedans by the 1830s.

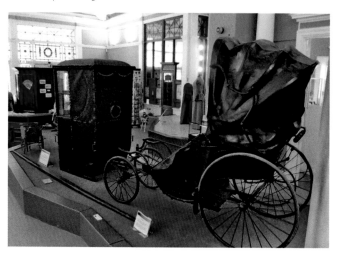

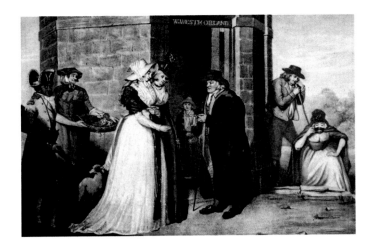

The Chalybeate Well at Harrogate ...

... by John Raphael Smith (1796), which is on display in the Mercer Art Gallery and shows the Sweet Well with people coming to take the waters, including two well-off women with their black servant. See page seven for the Well today. The Royal Pump Room in the modern picture dates from 1842 and was built under the auspices of the newly formed Improvement Commissioners, who were empowered to provide a suitable building to house the Sulphur Well – the world's strongest sulphur well. The original cover was moved to the Tewit Well, where it survives today. The Pump Room was designed by Isaac Shutt and cost £3,000. Stanhope was the first to differentiate between the clientele at the different wells, describing those here as 'the vulgar sort' and questioned the standards of hygiene when 'it was open for the promiscuous of all sorts ... so that the poor Lazar [the leprous] impotent people do dayly environ it, whose putrid rags lie scattered ... it is to be doubted whether they do wash their soares and cleanse their besmirched clouts, though unseen, where diverse persons after dippe their cups and drinke.' It seems that leprosy patients were tolerated when the well was open but when it became closed in they were no longer welcome.

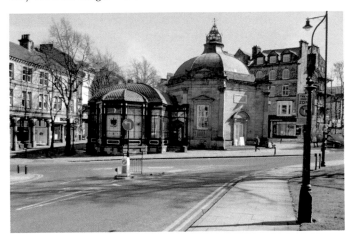

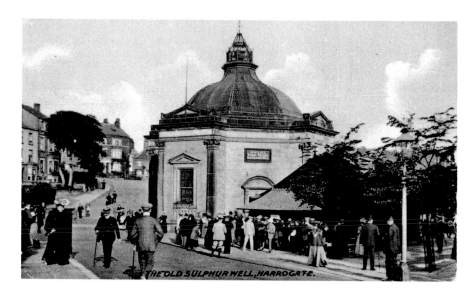

THE OLD SULPHUR WELL, HARROGATE.

Royal Pump and Kindness to Horses

Celia Fiennes, the first woman to visit every county in England, came to Harrogate on her grand tour – a journey she made on horseback and frequently accompanied by only one or two servants. This is how she described the Old Sulphur Well in her *Great Journey to Newcastle and to Cornwall*, 1698: 'there is the Sulpher or Stincking spaw, not Improperly term'd for the Smell being so very strong and offensive that I could not force my horse Near the Well ... the taste and smell is much of Sulpher' tho' it has an additionall offenciveness Like Carrion.' Despite this, the number of drinkers continued to rise from 3,774 in 1842, 11,626 in 1867 and 259,000 in 1925. Today's picture shows the original sulphur well on display at the museum.

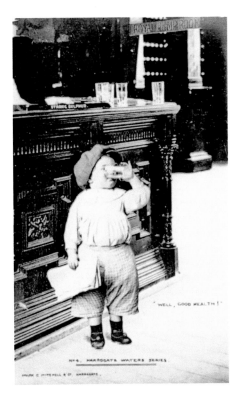

'Well Good Health' at the 'Stincking Spaw'
The Latin inscription on the Pump Room is *Arx celebris fontibus*, the old town motto at its 1884 Charter of Incorporation, loosely rendered as 'the town famous for its springs'. Betty Lupton is the lady who graces this chapter on page five. Old Betty, Queen of the Well, served the 'strong sulphur' water at the Old Sulphur Well for over sixty years before her death in 1843. A Dr Thorp analysed the waters here, 'Proven to be beneficial in most forms of Indigestion; Constipation, Flatulence and Acidity. For all cases of functional disorders of the liver. For stimulating the action of the kidneys and in all forms of Chronic Skin Diseases. To be drunk warm or cold. Dosage between 10–24 ounces to be taken early in the morning.' The contemporary photograph shows a detail of the fine window marking the 1933 extension.

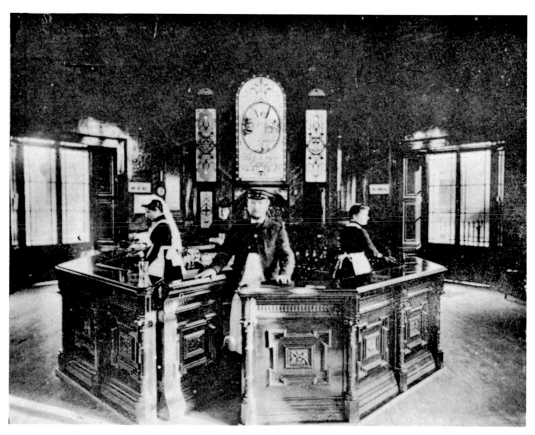

Inside the Pump Room

Attendants at the entrance to the Pump Room, with the beautiful window in the background. This can still be enjoyed in the museum. The author of the 1813 *Guide to All the Watering and Sea-Bathing Places* was less than complimentary: 'Harrowgate water tastes like rotten eggs and gunpowder; and though it is probable that no person ever made a trial of such a mixture, the idea it conveys is not inapplicable ... While some places are visited because they are fashionable, and others on account of the beauty of their scenery, Harrowgate possesses neither of those attractions in a superior degree, and therefore is chiefly resorted to by the valetudinary, who frequently quaff health from its springs, else we cannot suppose that upwards of two thousand persons annually visit this sequestered spot ... it lies ... on a dreary common'. How things were to change ...

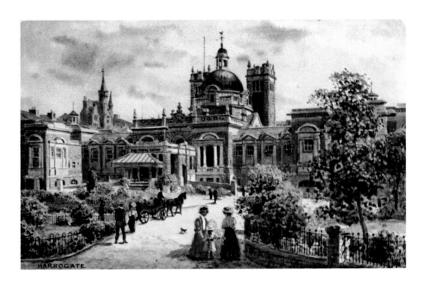

The Royal Baths

Built by Baggalay & Bristowe in 1897, on the site of Oddy's 1819 Saline Chalybeate Pump Room, the magnificent Royal Baths opened on 3 July 1897 and went on to provide some of the most advanced hydrotherapy treatments in the world. The baths gained a new wing in 1898 for the Peat and Plomieres Baths – the latter for the very popular Plombieres Two-way System or Harrogate Intestinal Lavage System, a colonic irrigation treatment that could result in the loss of half a stone in weight. They were extended in 1909 and 1911, and again in 1939 to include a new treatment wing, panelled lounge hall and the open-air fountain court. Used by the National Health Service from the late 1940s until 1968, they were then given over to private patients for a short period. By 1969, only the Turkish Sauna suite was in operation, but it remains one of the most beautiful of England's last remaining Victorian baths.

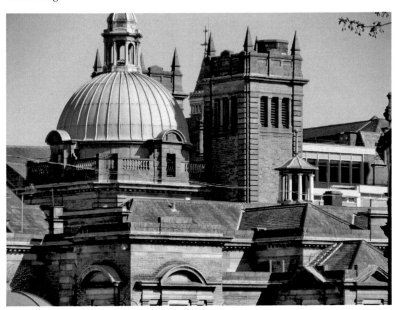

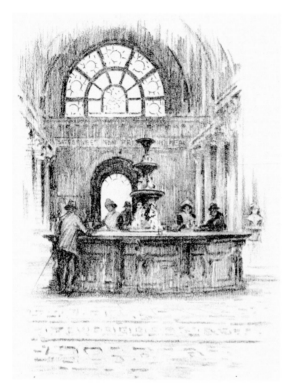

The Royal Baths and the Nasal Douche

The Royal Baths, built on the site of the Kissingen Well, offered around ninety different treatments catering for a wide range of disorders and diseases – real and otherwise. For many of these treatments, Harrogate and the Royal Baths in particular became a centre of excellence with an international reputation. Perhaps the most famous was the Saline Sulphur Bath which comprised two waters: Saline Sulphur and Alkaline Sulphur Water – the latter used in the treatment of skin disorders; the former for gout, rheumatism and liver disease. The Nasal Douche and Throat Sprays involved using a medical device that enabled the patient to inhale atomised mineral water to remove mucus attached to the inside of the nose thus, apparently, helping with normal circulation and secretions. The beautiful fountain is now in the Royal Pump Museum.

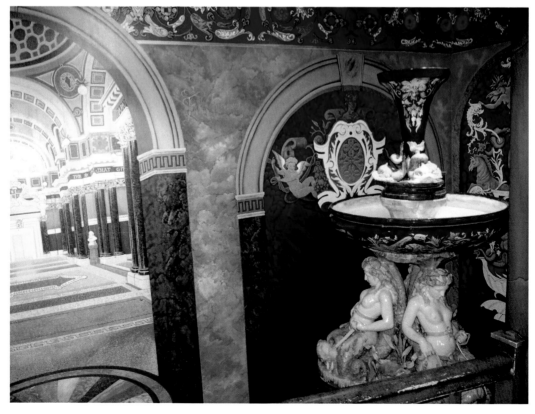

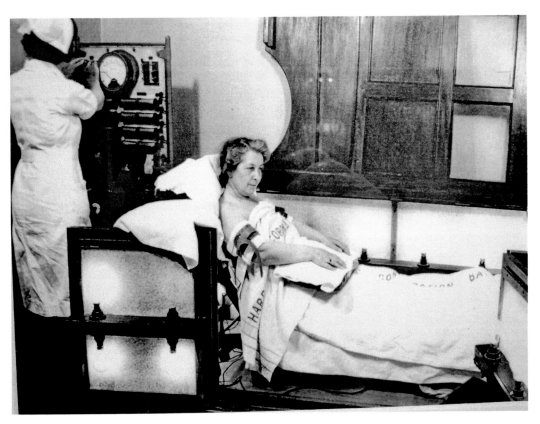

The Peat Bath

Peat baths were also very popular in the Royal Baths – there were four of them: Mineral Peat Bath, the Brine Bath, the Electric Bath and the Ordinary Peat Bath. The minerals for these were brought in from the North York Moors. The baths themselves were made of Burma teak and took one week to make. Peat baths were efficacious in cases of rheumatism, lumbago, sciatica and the like. The new picture shows an original Crapper lavatory still functioning in the Turkish Baths.

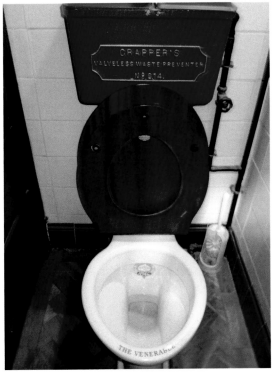

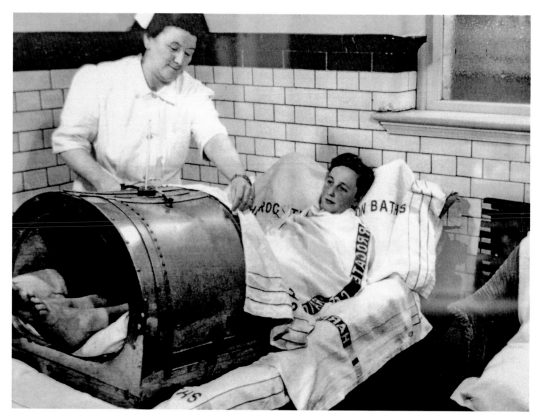

Voltaic Cages

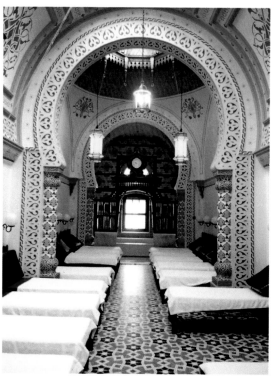

The Voltaic Cage Bath emitted pulses of electricity effective in the treatment of patients with polio and MS. The uniform of the female attendants was a long, bottle-green skirt, white blouse, large apron and a cap. Men wore a collar and tie and a jacket, which, in the temperatures involved, must have been insufferable. The laconium was heated to 79 degrees Fahrenheit and the caldarium a cool, by comparison, 55 degrees. One of the attendants' crucial jobs was to wipe the brows of clients, lest the steaming water scald their eyes. There were twenty women attendants and three men – as women were unable to undress themselves (the buttons on their dresses being at the back), each lady needed their own attendant. The modern picture and that on the next page show the treatment rooms today with the deep plunge pool under the clock.

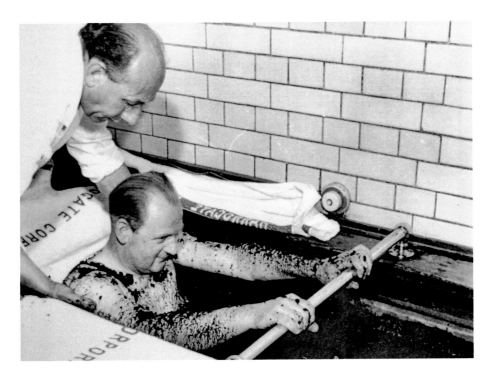

The Use and Abuse of the Harrogate Mineral Waters
The last peat bath, in 1966, for this Royal Bath Hospital, as captured on the Yorkshire TV news programme *Calendar*. By 1909, Arthur Roberts' definitive work was already in its fifth edition and it provides an exhaustive description of the myriad treatments available; from Sitz and Russian baths, Vichy Douche baths to Schwalbach baths, from Dr Schnee's four-cell baths for cataphoresis to Dowsing radiant light baths.

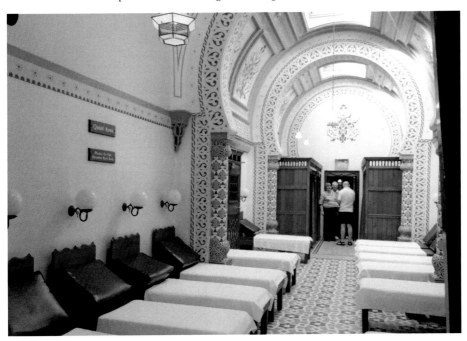

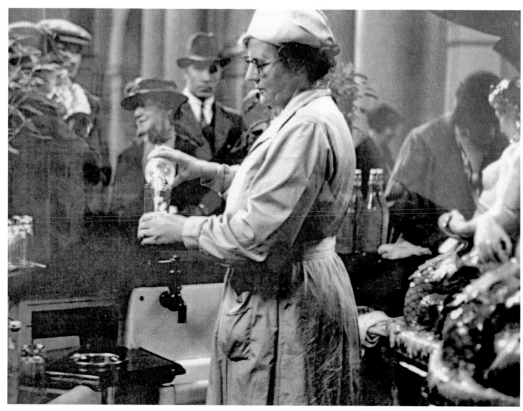

Baden Baden Comes to Harrogate

In 2008, the Royal Baths Chinese Restaurant opened in the Grand Pump Room, tastefully and sympathetically restored by Hak and Monica Ng. The water being served is mild afternoon water; it was scooped from the well and brought to reception for ladling.

Dr Sheridan Muspratt was responsible for pioneering analyses of the waters and their particular benefits in 1866 and 1867. Harrogate's reputation was such that workers at other spas, including Baden Baden, came here for training. The new picture shows one of the hot rooms today.

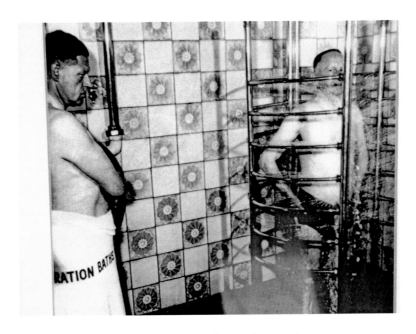

'The tub smoked and stunk like the pit of Acheron ...'

Things had picked up somewhat since Tobias Smollett's baleful description of his Harrogate spa experience in *Humphrey Clinker*: 'at night I was conducted into a dark hole on the ground floor, where the tub smoked and stunk like the pit of Acheron'. *Thorpe's Illustrated Guide* of 1886 gives us another list of complaints for which the sulphur waters provide effective therapy: 'pimples which rise with great itching, ulcerated tetters, scorbutic rash, shingles, leprosies, branny scales, scaly tetter, grog blossoms produced by intemperance.' It should be remembered that the shower would have been a novel experience for many visitors in a time when only bathing was available.

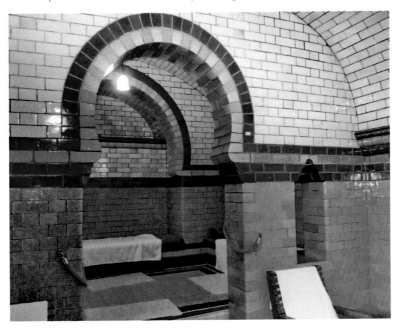

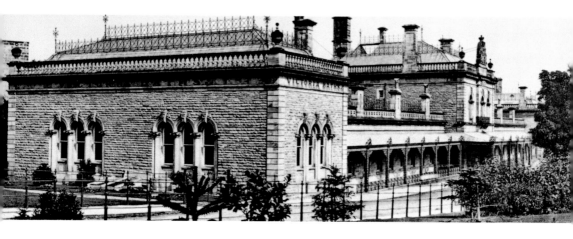

New Victoria Baths

Built at the behest of the Harrogate Improvement Commissioners in 1871, on the site of the 1834 Old Victoria Baths, they were originally called the John Williams' Baths, after the owner. The Commissioners used the upper floor in the central block as offices for a while. They were succeeded by the Council after 1884 and, when the baths closed in the 1920s, the building was later converted into a town hall, the council chamber of which is today virtually in the same place as it was for the Commissioners.

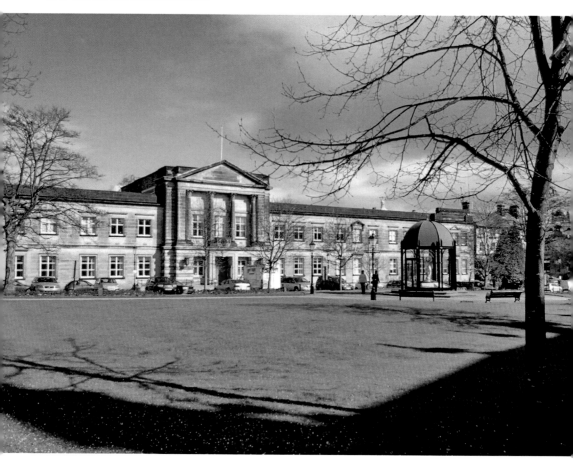

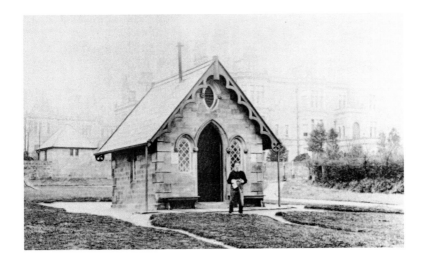

The Magnesia Pump Room

This Gothic-style building was constructed by the Improvement Commissioners in 1858, in Bogs Field, before it was incorporated into the Valley Gardens. Popular on account of its milder waters (today it would be branded 'Sulfur Lite'), the site is now occupied by a cafeteria. The Royal Bath Hospital can be seen in the background. By the mid-nineteenth century, the waters of Low Harrogate had become more popular than their High Harrogate neighbours', and this led to the plethora of baths down here at the time. This was all very different from the early days when, as Deane told us in 1626, 'the vulgar sort drinke these waters to expelle reefe and felon; yea many who are much troubled with itches, scabs, morphews, ring-worme, and the like are soone holpen'. Defoe in his *Tour Through the Whole Island of Great Britain* saw it differently in 1717: 'We were surprised to find a great deal of good company here ... though this seems to be the most desolate and out-of-the-world place, and that men would only retire to it for religious mortifications, and to hate the world, but we found it quite otherwise.' The Magnesia Well was closed in 1973.

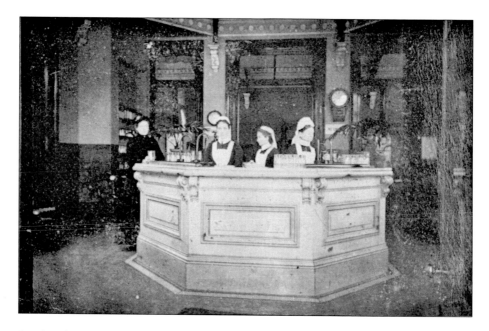

Serving the Waters at the Montpellier

A wonderful picture of the Montpellier water servers in the late nineteenth century. The modern picture is looking towards the Pump Room from where the Montpellier Gardens were. Established in 1835 by Joseph Thackwray – who also owned Montpellier gardens and the Crown Hotel – 6,000 baths were taken here in the 1839 season. For many years, Montpellier's were considered the best baths in town; they specialised in needle shower and douche baths and invalid Sitz baths.

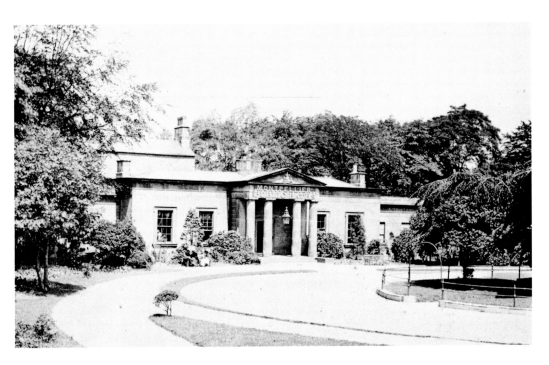

Montpellier Public Baths

Six new wells, including the famous Kissingen Well, were discovered when the foundations were being dug, no doubt to the delight of Thackwray. The small octagonal building that survives was originally a gatehouse and ticket office for the hotel's gardens.

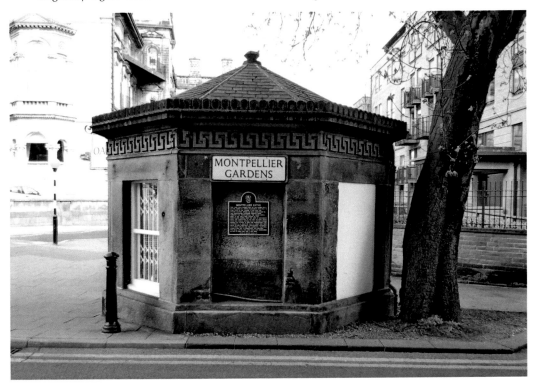

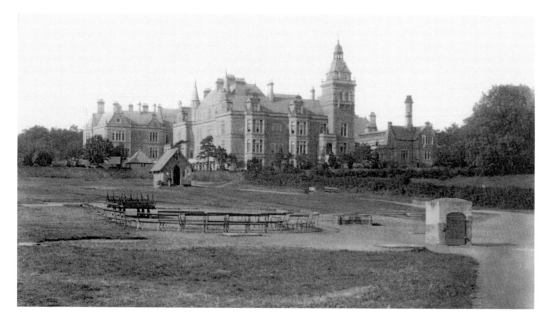

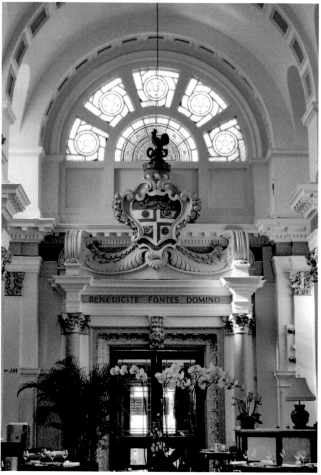

Royal Bath Hospital

This 1892 photograph shows the 150-bed Royal Bath Hospital and Rawson Convalescent home in Cornwall Road. It was built in 1889, at a cost of £50,000, on the site of the original forty-bed Bath Hospital, which dated from 1824. The purpose of the Royal Bath was to cater for poorer patients who could not afford to pay for the typical Harrogate treatments, and who lived at least three miles out of town. In 1931, 1,700 cases from all over the UK were treated. Originally, no waters were available onsite and patients had to go to places like the Royal Baths to take the cure. The hospital closed in 1994, but not before it had won a reputation as a centre of excellence for the treatment of rheumatoid diseases and as a leading hospital for hydropathic treatments. It is now the Sovereign Court residential development. The new photograph is of the beautifully restored interior of the Royal Baths.

Pullan's and *The Castle of Indolence*

J. R. Pullan, chemists, was established in 1829 at premises in Regal Parade, Harrogate Wells. They had, if this advertisement is anything to go by, quite a specialisation in podiatry. The contemporary photograph shows the inscriptions around the cornice – very appropriate lines taken from James Thomson's 1748 *The Caſtle of Indolence: An Allegorical Poem. Written in Imitation of Spenſer:*

> *Ah! What avail the largest gifts of heavan*
> *when drooping health and spirits go amiss*
> *how tasteless then whatever can be given*
> *health is the vital principle of bliss,*
> *and exercise of health.*
> *Then in life's goblet freely press*
> *the leaves that give it bitterness:*
> *Nor prize the healing waters less,*
> *for in the darkness and distress*
> *new light and strength they give.*

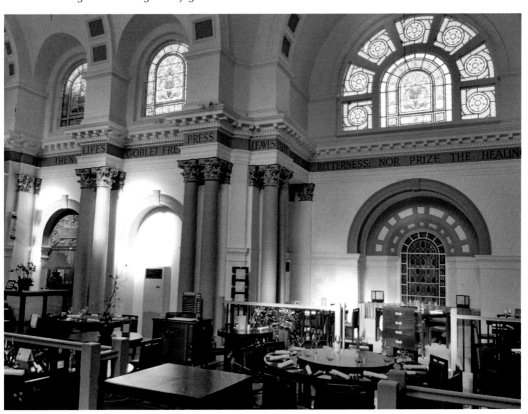

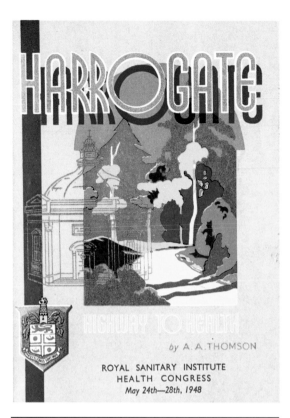

ROYAL SANITARY INSTITUTE
HEALTH CONGRESS
May 24th—28th, 1948

Harrogate – Highway to Health
With the decline of the spa, the town had to reinvent itself, through the establishment of an industry based on conferences and exhibitions. Accommodation, ambience and amenities were all more or less already in place. This programme is from an early event, the Royal Sanitary Health Congress, which took place in May 1948 and neatly combines the town's history of providing health-giving services and facilities with its emerging role as a major conference venue. Exhibition halls were developed, and the International Conference Centre opened in 1981 at a cost of £34 million. The newer image shows how Harrogate was a key venue on the emerging popular music circuit in the early 1960s.

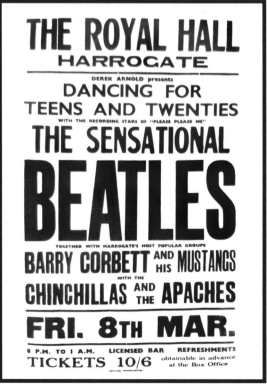

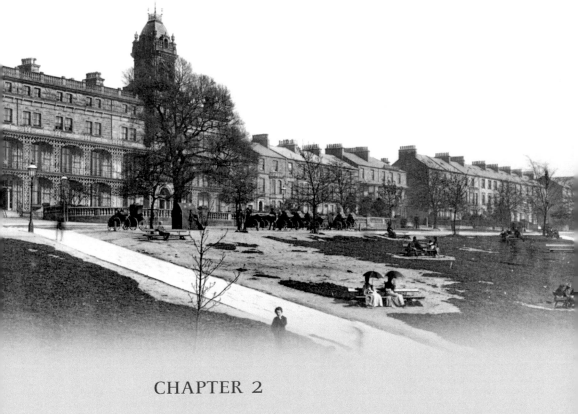

CHAPTER 2

The Harrogate Hotels

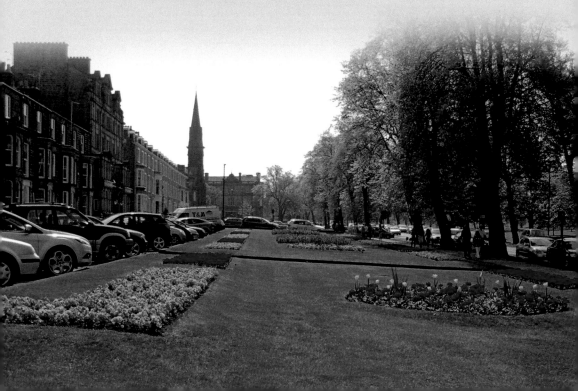

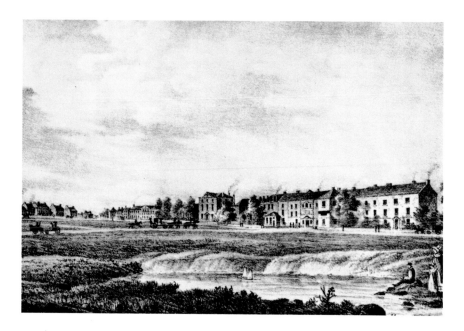

The Granby Hotel

Harrogate's reputation for fine hotels grew from a need to accommodate the increasing numbers of visitors to what soon became one of Europe's finest spas. Former names of the Granby include the Sinking Ship (a reference to the defeat of the Spanish Armada) and the Royal Oak. Royal Oak was its name when Blind Jack of Knaresborough played his fiddle there, and Harrogate's first theatrical productions were held in the barn. It was renamed the Granby in 1795. Blind Jack allegedly eloped with the landlord's daughter on the eve of her wedding in the 1830s. Guests have included Laurence Sterne and Robert, Clive of India. The Granby is now Granby Court Care Home.

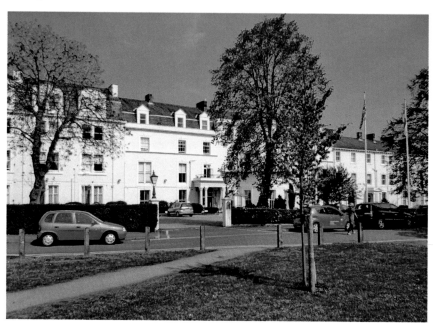

Dragon Hotel and the Dunmow Fitch

First records of the Dragon (named after a Charles II racehorse) go back to 1764 when the owners, the Liddals, won the famous Dunmow Fitch, which entailed married couples going to Dunmow, Essex, and swearing that for a year and a day they had never had a quarrel and never wished themselves not married. It was also called the Green Dragon and was owned between 1827 and 1830 by Thomas Frith, father of the painter W. P. Frith. In 1870, it became High Harrogate College, and was demolished in the 1880s to make way for Mornington Crescent. Many of the hotels grew out of farmhouses: the popularity of the town as a spa rather took it by surprise and many visitors were initially accommodated in extended farmhouses, eating produce from the farms. The Dragon, Granby and Queen all were originally farms – all three are in High Harrogate, close to the St John and Tewit Wells.

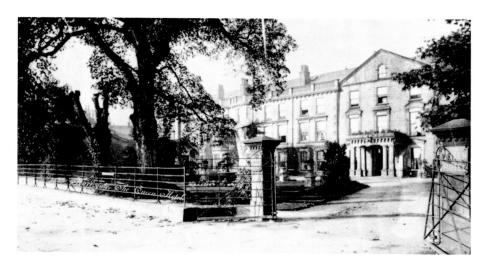

The Queen Hotel

The hotels soon acquired nicknames, characteristic of their clientele. The Granby, popular with the aristocracy, was known as 'The House of Lords'; the Dragon was 'The House of Commons' due to its patronage by the military and the racier set; the Queen was frequented by tradesmen and merchants and was known as 'The Manchester Warehouse'. The Crown was known as 'The Hospital' because it was close to the Old Sulphur Well. The Queen was probably named after Charles II's wife, Catherine of Braganza; now the Cedar Court, it was reputedly Harrogate's first purpose-built hotel. Blind Jack was resident fiddler here around 1732. Like the Grand, the Queen was requisitioned by the Empire Pilot's Receiving Scheme during the Second World War. It became the headquarters for the regional health authority in 1950, but happily reverted to its intended use in 1990.

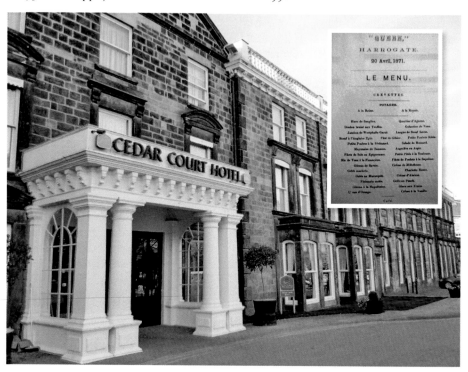

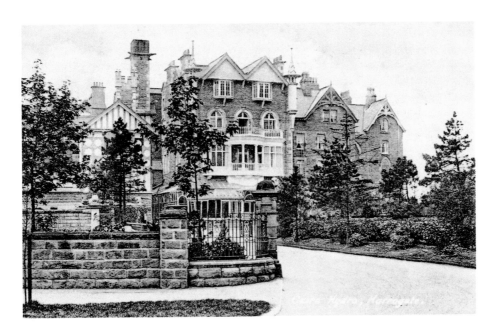

The Cairn Hydro

Built in 1890, the hotel was renamed the Cairn Hotel. In 1896, £2 9s to £3 10s got you bed, attendance, table d'hôte, breakfast, luncheon, afternoon tea, a free bath every morning and a copy of the *Cairn Times*. Evidence that the very early inns or hotels were somewhat low rent comes from Lady Verney in a letter of 1665: 'We arrived att the nasty Spaw, and have now began to drinke the horrid sulphur watter, which allthowgh as bad as is poasable to be immajaned, yet in my judgement plesent to all the doings we have within doorse. The House and all that is in it being horridly nasty, and crowded up with all sorts of company, which we eate with in a roome, as the spiders are ready to drop into my mouth, and it sure hathe nethor been well cleaned nor ared this dousen years; it makes me much more sicke than the nasty watter.' Unlikely that she went back ...

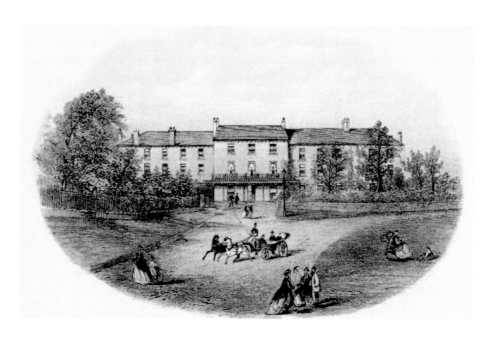

The Swan

The Swan Inn was built around 1700 as the Old Swan and run by Jonathan Shutt, who began receiving visitors at 'the Sign of the Swan'. In 1820, it was rebuilt and named the Harrogate Hydropathic, reverting first to the Swan Hydropathic and then to the Swan Hotel in 1953. The Hydropathic had 200 bedrooms, each with a coal fire, and was the first in Harrogate to be lit by electricity. The first resident physician (and one of the directors) was a Dr Richard Veale; it was originally modelled on Smedley's Hydro at Matlock. To make it fully compliant with its health objectives, the Hydro sacrificed its alcohol licence, banned smoking and made morning prayers compulsory.

The Hornblower and the Swan

The swan sign was made to commemorate the Coronation of Queen Elizabeth II in 1953. The Beatles stayed here during their 1963 visit for the concert at the Royal Hall; General Manager Geoffrey Wright was appalled at the idea of them darkening his portals. The group had tried to get into the Hotel St George, but were turned away because their appearance was deemed inappropriate. It had not always been clean living and the high life. In 1821, the people of Harrogate had complained to the council about sporadic vandalism: 'During the night some persons unknown ... have put into the mineral springs some quantities of Dung, Ashes, Dead Dogs, and other animals of a most offensive nature.' In 1841, the Harrogate Improvement Act was passed to protect the springs.

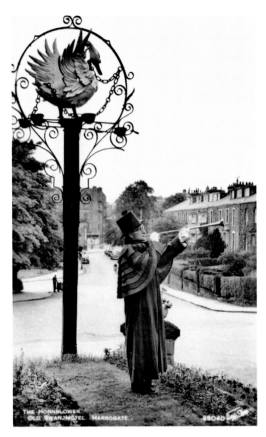

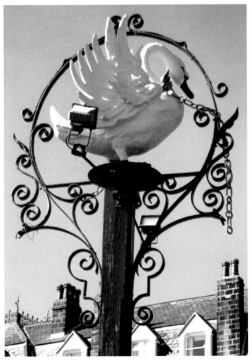

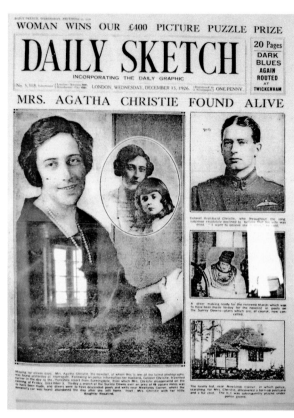

Agatha Christie and the Swan
In 1926, Agatha Christie took refuge here. She had left her home in Sunningdale, Berkshire, at around 9.45 p.m. on 3 December, abandoned her car perched precariously on the edge of a chalk pit and caught a train to Harrogate after seeing a railway poster advertising the resort. She checked in under the name of Theresa Neele, the name of her husband's mistress, and so began the hotel's association with murder, mystery and suspense. Meanwhile, a nationwide search was underway, the first in the country to involve aeroplanes. After ten days, Bob Tappin, a banjo player at the hotel, recognised Mrs Christie and alerted the police. In 1979, the film *Agatha* was released, starring Vanessa Redgrave, Dustin Hoffman and Timothy Dalton, some of which was shot in the Swan and nearby.

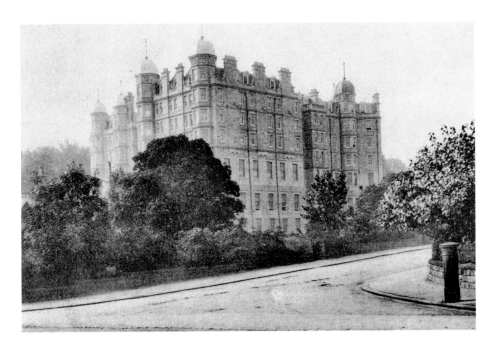

The Grand Hotel, or the Furness Military Hospital

Opened in 1903, on Cornwall Road opposite the Sun Pavilion, the former Grand Hotel is now Windsor House and home to offices. During the First World War, it was converted into the Furness Military Hospital. In common with other hotels in the town, it was requisitioned by the Ministry of Defence during the Second World War too, for the Empire Pilot's Receiving Scheme. Unfortunately, it struggled to re-establish itself as a hotel post-war. The lounge was famous for its tapestries depicting old Harrogate and murals illustrating English spas. Conri-Tait and his band were the resident entertainment in the 1930s.

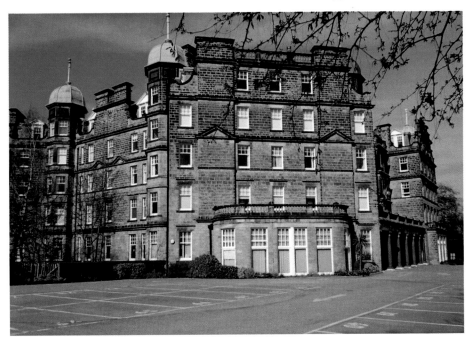

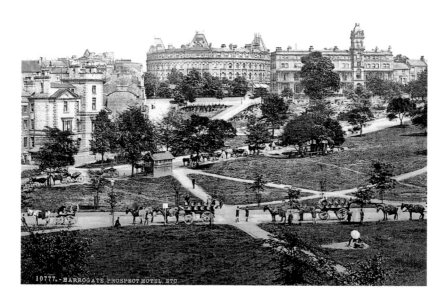

10777.—HARROGATE. PROSPECT HOTEL, ETC.

The Prospect Hotel

A rank of bath chairs outside the 1859 hotel: 1s 3d for the first hour and 4d for every quarter of an hour after that. Before the age of the bath chair, transportation was more basic: in 1660, the local constable claimed 7d for 'carrying one cripple to Harrogait on horseback'. In 1810, a journalist by the name of Henry Curling had waxed lyrical about the town: 'What scenes of life have we not beheld at Harrowgate. What days of romance and nights of revelry and excitement have we not passed ... where mothers trotted out their daughters in all their charms and country squires learnt the trick of wiving.'

Hotel Majestic and Sir Blundell Maple's Bill

The Majestic's origins lie in a dispute between a local businessman, Sir Blundell Maple, and the Queen Hotel. On checking his bill one morning, Sir Blundell spotted an error. Not receiving satisfaction from the Queen's manager, he stormed out, threatening to build a hotel that would put the Queen out of business. And so was born the Majestic: fine hotel as it was and is, it nevertheless failed to ruin the Queen. Guests included Elgar, Winston Churchill, Errol Flynn and George Bernard Shaw. The old photograph shows the site on which the hotel was built.

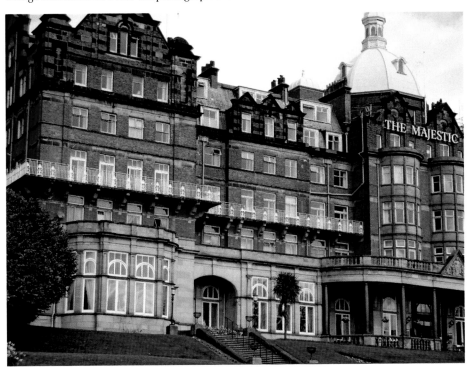

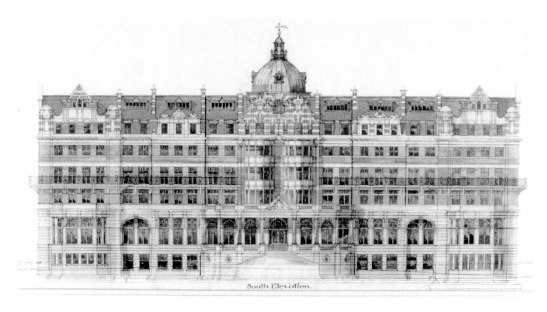

South Elevation.

Hotel Majestic and the Ugly Water Servants

Thomas Baskerville (*d.* 1840), surgeon and botanist, speaks of his irritation at the over-eager water servants invading even hotel rooms to ladle out the water: "'I am pretty Betty, let me serve you" ... "Kate and Cozen Doll, do let we tend you ..." but to tell the truth they fell short of that for their faces shone like bacon rine. And for beauty may view with an old Bath guide's ass.' The old photograph is of the original architect's plans for the hotel's south façade; the corresponding modern shot is of the nearby Harrogate International Centre undergoing the building of an extension.

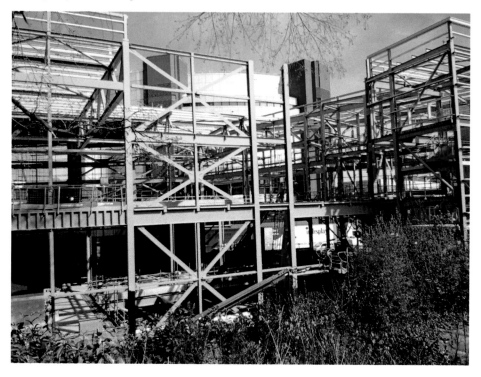

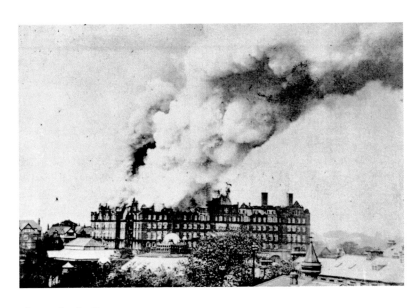

The Majestic Fire

The hotel was badly damaged by fire in 1924, causing £50,000 worth of damage. It also has the dubious distinction of receiving one of Harrogate's three bombs during the Second World War – the result of the hotel being listed as a target for German bombers in 1940 because German intelligence wrongly had it down as housing the Air Ministry. Indeed, Harrogate was second in the list of priority targets, which included Hughendon Manor at the top (headquarters of Fighter Command), garrisons, the headquarters of Bomber Command, the Admiralty and other sensitive installations. In the event a Junkers 88 dropped three bombs at midday on 12 September 1940: one exploded in the hotel gardens, one on the corner of Swan and Ripon Roads – demolishing a house – and the other hit the Majestic but failed to explode. This was rendered safe by Captain G. H. Yates of the bomb disposal squad.

Spalte 1 Ziel Nr.	Spalte 2 Bezeichnung des Zieles	Spalte 3 K. Bl. Nr. 1:100 000	Archivunterlagen St K	a	b c	b	c	Spalte 9 Bemerk.
13. 1	High Wycombe, Schloß Hughenden. Stabsqu. d. Fighter Command.	E 29	O	O			O	
13. 2	Harrogate, 1. Hotel Majestic, 2. Hotel Esplanade, Stabsqu. d. Luftfahrtministeriums	E 9	O	O			O	
13. 3	Stanmore, Stabsqu. d. Bomber Command.	E 29	O	O	O			Z.K. 1 b
13. 4	Ruislip, Rec. Off. d. R.A.F.	E 29	O	O	O			Z.K. 1 b
13. 5	Portsmouth, Kasernen	E 38	O	O	O			Z.K. 3/4
13. 6	Canterbury, Kasernen	E 40	O	O	O			
13. 7	Swindon-Watchfield. Kasernenanlage	E 28	O	O	O			
13. 8	Portsmouth-Hilsea. Kasernen	E 38	O	O	O	O		Z.K. 3/4
13. 9	Pembroke Dock, Kasernenanlage	E 20	O	O	O			Z.K. 8 a
13. 10	Prestatyn, Kasernenanlage	E 44	O	O	O	O		
13. 11	London, Whitehall. Kriegsministerium	E 34		O		O		Z.K. 1 b
13. 12	London, Mayfair Square, Admiralität	E 34		O		O		Z.K. 1 b
13. 13	London, Mayfair Square, Neues Luftfahrtministerium, Techn. Amt	E 29		O		O		Z.K. 1 b
13. 14	London, Thames House, Zentrbür. d. Flugzeugprod.	E 34		O		O		Z.K. 1 b
13. 15	London, Savoy Hotel u. Somersethouse Zentralbüro d. Flugzeugproduktion	E 29		O		O		Z.K. 1 b
13. 16	London, Somersethouse u. Tothill Street, Versorgungsministerium	E 34		O		O		Z.K. 1 b
13. 17	London, Tothill Street. Inform.-Ministerium	E 34		O		O		Z.K. 1 b

The HOTEL MAJESTIC

HARROGATE

The finest Spa Hotel in the World

Telephone HARROGATE 2261 Telegrams MAJESTIC HARROGATE

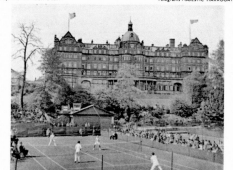

THE HOTEL MAJESTIC is the leading Hotel in Harrogate. It commands an unrivalled position overlooking the Royal Baths and Pump Room. It is surrounded by its own grounds extending to ten acres, and provides all the amenities demanded of a first-class residential Hotel. Luxurious private suites comprising sitting room, one or more bedrooms and private bathroom are available as well as over one hundred bedrooms with private bathrooms. The public rooms are commodious and artistically appointed. A first-class Orchestra plays daily in the Lounge, and the Saturday evening Dinner Dances are a feature of Yorkshire social life. There are two Championship Squash Courts with direct access from the Hotel. Tennis Courts and Putting Greens are available in the grounds. Special diets for visitors taking the cure are a feature of the Hotel. Intending visitors are invited to write to the Manager for illustrated tariff.

Those about to visit Harrogate in search * **Proprietors**
of health or pleasure should write to the **The Frederick Hotels**
Manager for illustrated tariff **Limited**

It will be of mutual benefit if you will mention this guide book

60

The 'Finest Spa Hotel in the World'

To back up this ambitious claim, the 1948 advert goes on to list the facilities, which included 'commodious and artistically appointed' public rooms; 'a first-class Orchestra plays daily in the Lounge, and the Saturday evening Dinner Dances are a feature of Yorkshire Social Life. There are two Championship Squash Courts ... Tennis Courts and Putting Greens are available in the grounds ... special diets for visitors taking the cure are a feature of the hotel'. Guests have included Edward Elgar, in 1927, who tetchily declared, 'Harrogate thinks of itself very fashionable and more than a little chic, and the ladies dress up terribly.' Could we expect anything better from a man whose birthplace was close to Malvern?

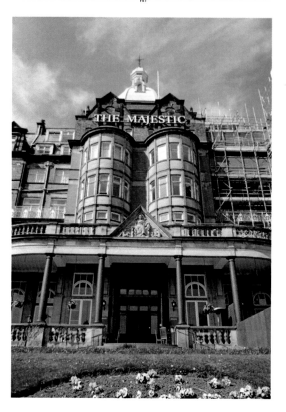

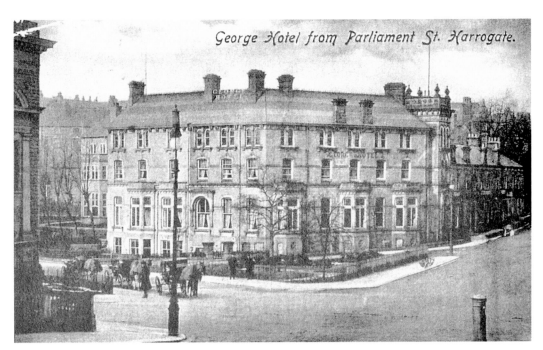

George Hotel from Parliament St. Harrogate.

St George Hotel

The St George Hotel, opposite the Kursaal, developed slowly but surely from its origins as a small cottage. From 1778 it began to offer the services of an inn. On 9 May 1910, Princess Victoria, the King's sister, and the Grand Duchess George of Russia watched from a window the proclamation of George V as King and Emperor on the steps of the Royal Baths. Other 1930s Harrogate accommodation included the Harrogate Food Reform Guest House in St Ronan's Road where 'dieting is understood'; while Miss Hamilton, at the Octagon Boarding House, ensures a 'liberal table'.

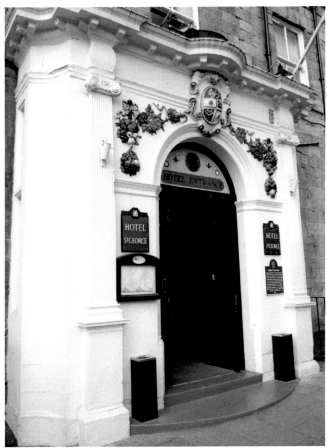

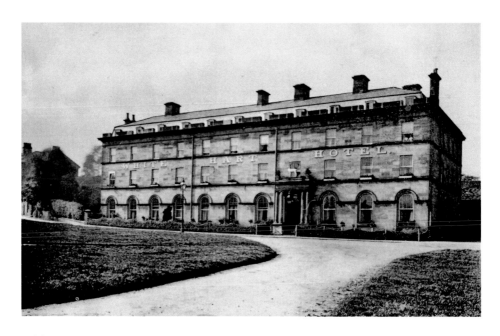

White Hart Hotel in 1869

Built in 1846, this neoclassical building is, in Pevsner's estimation, 'easily the best building in Harrogate ... with nothing gaudy or showy about it'. Tobias Smollett stayed in the town in 1766 and describes his time here in *Humphrey Clinker*: Harrogate was 'a wild common, bare and bleak, without tree or shrub or the least signs of cultivation'. Charles Dickens visited the Spa Rooms to deliver some readings in 1858 and said, 'Harrogate is the queerest place with the strangest people in it, leading the oddest lives of dancing, newspaper reading and tables d'hôte'. The Jarrow Crusaders paused here on the Stray to the front of the hotel in 1936.

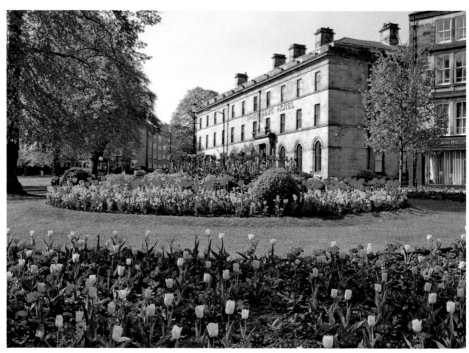

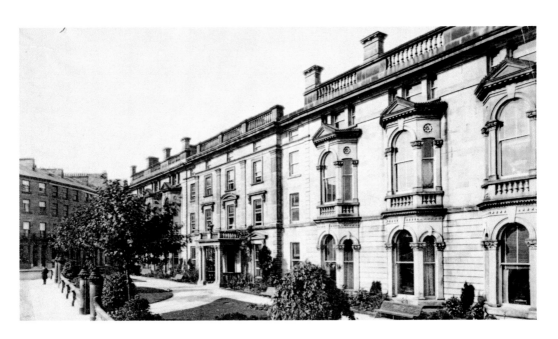

The Crown

Built originally in 1740 by Joseph Thackwray, great uncle of the owner of Montpellier Square and Gardens, it was renovated in 1847 and again in 1870. Thackwray was given permission to buy the Crown by King George III, in 1778. In 1784, the head waiter, William Thackwray, was making so much money that he was able to buy the Queen Hotel. Thackwray was no fool: in 1822 he discovered a number of new wells, one of which was a sulphur well called the Crown Well, and another he channelled into the back yard of the Crown.

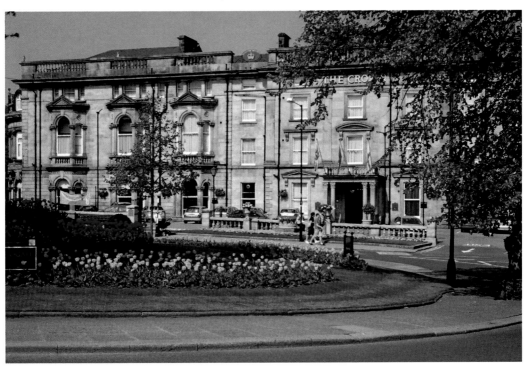

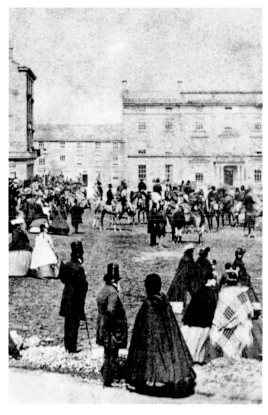

Lord Byron, the Crown and the Quaker Girl

An early photograph, of around 1865, showing a meet outside the Crown. Lord Byron stayed in 1806 with 'a string of horses, dogs and mistresses'. Whilst here he wrote 'To a Beautiful Quaker' inspired, it seems, when he happened to notice a pretty Quaker girl. The following extract (the first stanza of the poem) is taken from the first edition of *Fugitive Pieces* published in *1806*.

> *Sweet girl! though only once we met,*
> *That meeting I shall ne'er forget;*
> *And though we ne'er may meet again,*
> *Remembrance will thy form retain.*
> *I would not say, "I love," but still*
> *My senses struggle with my will:*
> *In vain, to drive thee from my breast,*
> *My thoughts are more and more represt;*
> *In vain I check the rising sighs,*
> *Another to the last replies:*
> *Perhaps this is not love, but yet*
> *Our meeting I can ne'er forget.*

Elgar visited in 1912. During the Second World War, the Government requisitioned the Crown for the Air Ministry – they finally vacated in 1959.

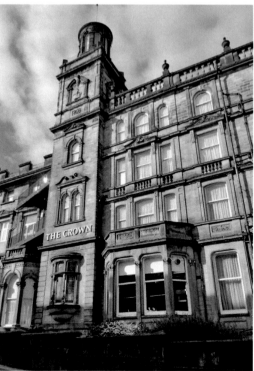

GRAND
OPERA HOUSE
HARROGATE

CHAPTER 3

A Harrogate Night Out

Miss Harriet Melon in the Barn and the Regency Theatre

The 1788 Regency Theatre had close associations with actor-manager Samuel Butler's Georgian Theatre in Richmond, and shared actors and productions with his other theatres in Beverley, Kendal, Northallerton, Ripon, Ulverston and Whitby. The owner of the Granby Hotel in 1788, Mrs Wilks, built the theatre in Church Square, and before this it was in the barn at the Granby – a common situation for theatres in England at the time, giving rise to the word 'barnstormers'. Hollins's 1858 *Illustrated Handbook* tells us about the barn: 'There it was that the celebrated Miss Melon used to delight her audience, and where her genius shone forth in a blaze of triumph, which completely obscured the light of twelve penny candles flickering in bottles around her.' The theatre closed in 1830 and became a private house (Mansfield House) as it remains today. The newer picture shows the inside of Harrogate Theatre now.

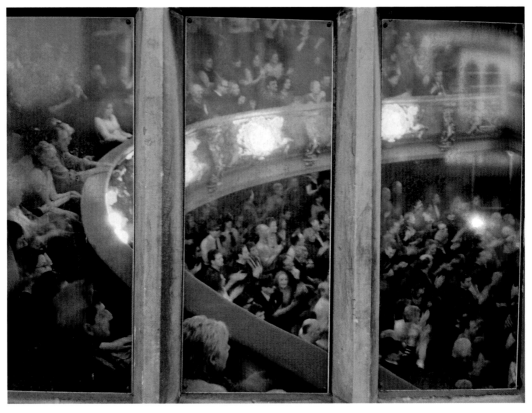

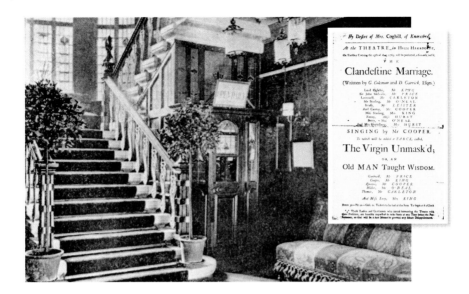

The Grand Opera House

Opened in 1900, in Oxford Street, the premiere was a charity gala, *The Gentlemen in Khaki*, in aid of British soldiers fighting the Boer War. Next on was a run of *Dick Whittington*. Designed by Frank Tugwell, who also designed the Futurist Theatre in Scarborough and the Savoy Theatre in London, it incorporated many of the latest safety features: a fireproof curtain that could be lowered between the stage and the auditorium, fire extinguishers and a sprinkler system; as well as hot and cold running water in the dressing rooms and electric lighting. The original capacity was 1,300, later reducing to 800. In 1958, the theatre reopened as Harrogate Theatre and in the early 1970s was extensively refurbished, with capacity reducing to 480. Over the years, many famous performers have appeared at Harrogate, including the d'Oyly Carte Company, Trevor Howard, Charlie Chaplin, Sarah Bernhardt, Martin Shaw, Ben Kingsley and, in 2011, the Gruffalo. The modern picture shows the impressive Art Nouveau frieze which circumscribes the foyer.

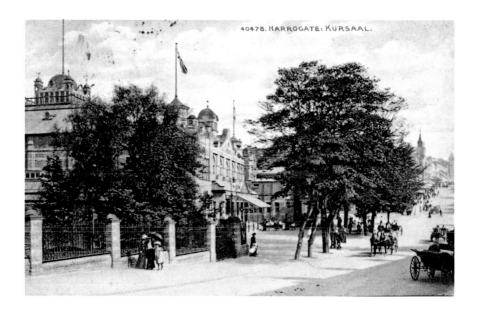

40478. HARROGATE: KURSAAL.

The Kursaal

Loosely modelled on Ostende Kursaal, in Belgium, the Kursaal was opened in May 1903 by Sir Hubert Parry (of 'Jerusalem' and 'I Was Glad' fame) on the site of Bown's 1870 Cheltenham Pump Room. Early attractions included Sarah Bernhardt, the Halle Orchestra, Pavlova and Dame Nellie Melba. The name Kursaal (Cure Hall) comes from the buildings so named and popular in continental spa towns. In Harrogate, the name was changed in 1918 to the less Teutonic Royal Hall and boasted 1,276 seats. The Kursaal came about as a response to the growing demand for entertainment in Harrogate and, because at the time the popularity of Chloride of Water was declining, the pump room was demolished to make way for it.

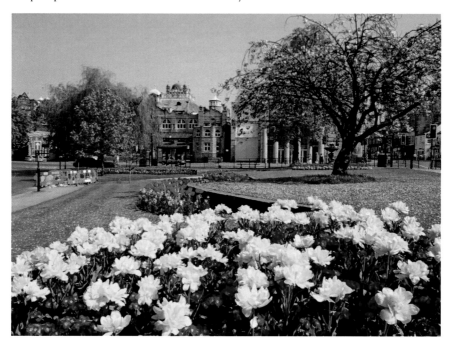

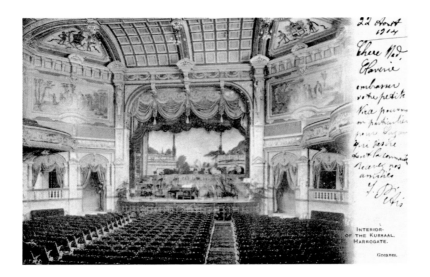

INTERIOR-
OF THE KURSAAL,
HARROGATE.

Greaves.

'A Palace of Glittering Gold'

That is how the *Harrogate Advertiser* described the Royal Hall when it reopened in 2008 after its £10 million refurbishment. Indeed, there is more gold leaf here than in any other similar auditorium in Britain. In earlier years, royal visitors were commonplace, as it were. On one day in 1911, three queens were in town: Queen Amelia of Portugal, Empress Marie of Russia and Queen Alexandra, Edward VII's widow. Other pre-war royalty included Princess Victoria, King Manuel of Portugal, Prince Henry of Prussia (the Kaiser's brother) and Prince Christopher of Greece. Performers at the Kursaal have included Parry, Elgar, Vaughan Williams, Stanford, Laurel & Hardy, Paul Robeson, Gracie Fields. The Beatles played here on 8 March 1963. Less savoury visitors included Sir Oswald Mosley, who spoke at a sold-out 1935 Royal Hall rally, and William Joyce, hanged in 1946 for his 'Lord Haw Haw' pro-Nazi broadcasts, who made many British Union of Fascists fundraising trips to the town.

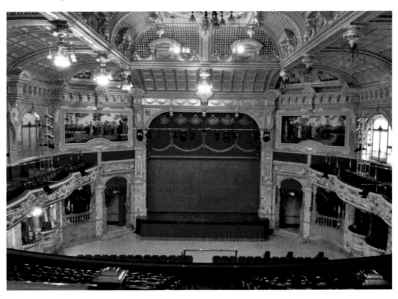

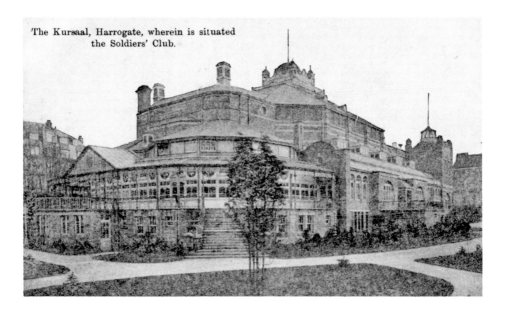

The Kursaal, Harrogate, wherein is situated the Soldiers' Club.

Royal Hall Soldiers Club

The breathtaking Royal Hall is now an integral part of Harrogate International Conference Centre, which opened in 1981 – the result of a decision in the 1960s to keep Harrogate on the world stage, and thus ensure its economic survival. By using the buildings and services that had catered for the town as a spa, Harrogate turned into a conference and exhibition venue of considerable importance. In 1959, a temporary hall was set up in the Spa Rooms and Gardens and the town was able to accommodate the prestigious toy fair a few years later. Today, over 2,000 events take place in the centre each year, bringing in nearly £200 million.

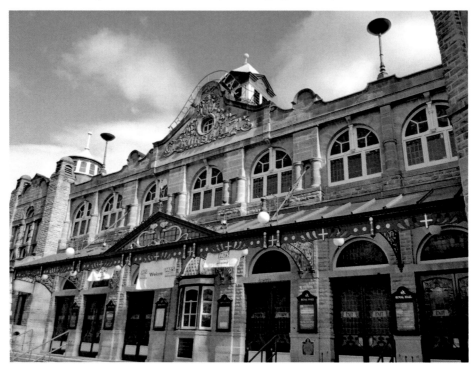

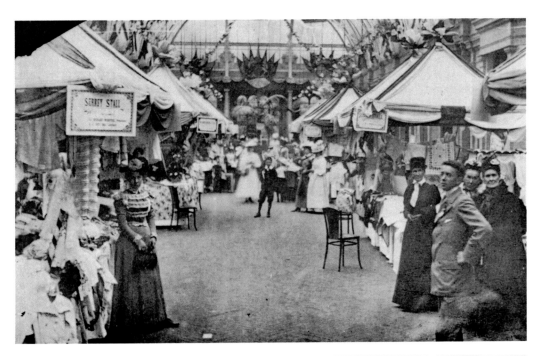

Cricket Club Bazaar at the Winter Gardens

John Feltham's 1804 *Guide to All the Watering and Sea-Bathing Places* tells us how Harrogate society worked and notes the practice of men and women remaining in the same room after dinner whereby 'the ladies, by this custom, have an opportunity of witnessing the behaviour of gentlemen; and the latter of determining how well qualified the former may be for presiding over a family.' On entertainment generally: 'Deep play, of any kind, is seldom practiced at Harrowgate; the person who could renounce female society, which is here to be had without difficulty, for a pack of cards, or a faro bank, would be generally avoided. Another advantage of mixing freely with the ladies, is the sobriety it ensures; to which the waters, indeed, contribute not a little.' The modern picture shows the Winter Gardens today.

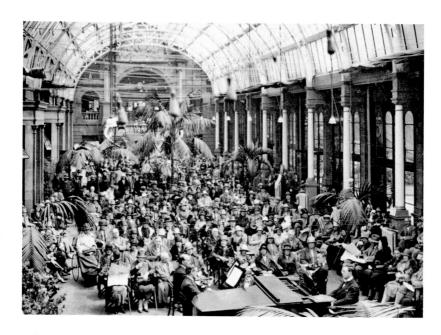

Palm Court

A concert in full swing in the Winter Gardens in the 1920s – possibly Cecil Moon's Palm Court Trio. Popular it certainly was, with standing room only; however, not everyone was transfixed: take a look at the two ladies and gentleman at the front, on the left, ensconced in their newspapers and book; likewise those on the right behind the pianist. The Gardens were opened in 1897 and demolished in 1936 when the Lounge Hall and Fountain Court were built to replace them. All that remains are the original stone entrance foyer and staircase. Today Wetherspoon runs the establishment, but the days of such top-class entertainment by the likes of Britten, Segovia, duPre, and Menuhin are over.

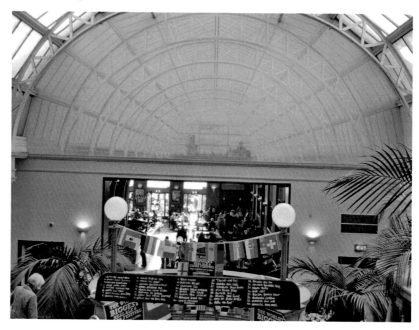

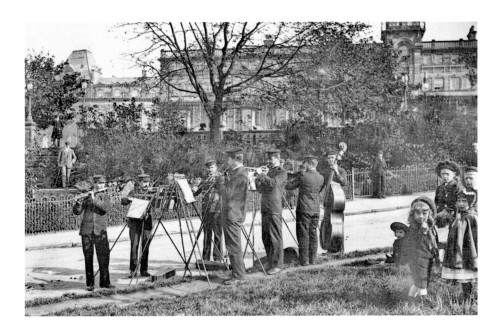

Otto Schwartz and his Band

This shot from 1903 shows Otto Schwartz and his seven-piece band playing one of their frequent concerts outside the Prospect Hotel. Schwartz is the one on the left playing the flute. Entertainment of a different sort came in the composition of verses on the town and its visitors; one example describes a Benjamin Blunderhead: 'And that night for the first time I stagger'd to bed, / With more wine on my stomach than sense in my head, / But a dose of the water as soon as t'was day, / Dispers'd all my headache and left me quite gay.' The new photograph shows one of the many street bands that play around the Cenotaph in today's Harrogate.

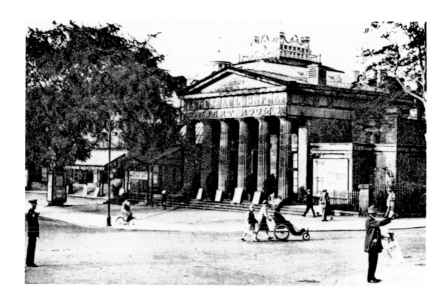

Cheltenham Spa Rooms

A magnificent 1835 classical building with superb Doric columns, which was constructed to complement the Cheltenham Spring, so-called because the waters were considered similar to those in Cheltenham. This had been discovered in 1818 and was soon regarded as the best Chloride of Iron spring in Europe. Increasing demand led to the building of a new pump room in 1871, by Bown, in the style of a miniature Crystal Palace. The building later became known as the Royal Spa Concert Rooms. The modern picture is of the interior of the refurbished Royal Hall, which was built near the site. The six acres of gardens featured a boating lake and skating rink with a pump room and colonnade, built in 1870. The Corporation bought the Rooms in 1896 and demolished the lot in 1939. The pillars survive though and can be seen at RHS Harlow Carr.

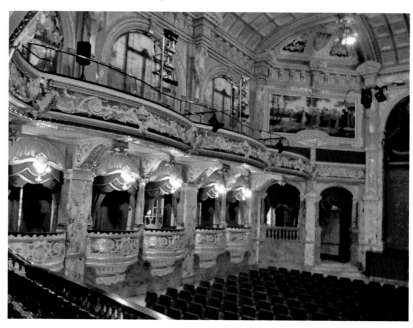

CHAPTER 4

Harrogate Business

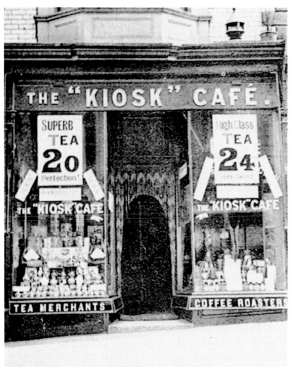

The 'Kiosk' Café

The story of Bettys begins in September 1907 when a twenty-two-year-old Fritz Butzer arrived in England, from Switzerland, with no English and less of an idea of how to reach a town that sounded vaguely like *Bratwurst*, where a job awaited him. Fritz eventually ended up in Bradford and found work with a Swiss confectioner's called Bonnet & Sons, at 44 Darley Street – whether Bradford was the original objective and whether Bonnet's was the intended employer is doubtful – who paid him the equivalent of 120 Swiss francs per month with free board. Cashing in on the fashionability of all things French, Fritz changed his name to Frederick Belmont. The old picture here shows the first Café Kiosk at 16 James Street; the new one is the interior of the busy shop in Bettys Café.

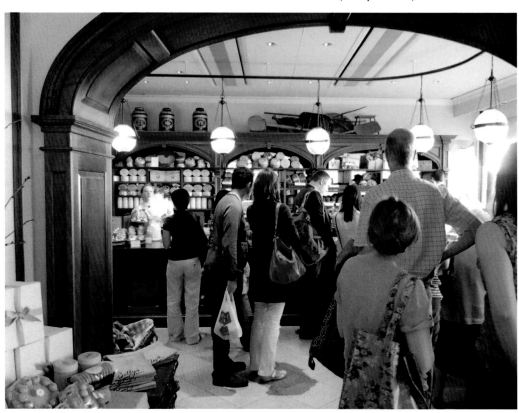

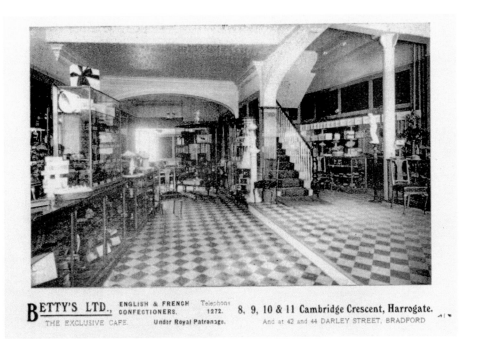

BETTY'S LTD., ENGLISH & FRENCH CONFECTIONERS. Telephone 1272. 8, 9, 10 & 11 Cambridge Crescent, Harrogate.
THE EXCLUSIVE CAFE. Under Royal Patronage. And at 42 and 44 DARLEY STREET, BRADFORD

Bettys and the *Queen Mary*

A bakery was built in Starbeck, in 1922, followed by tea rooms in Bradford (in the premises of Bonnet's, Belmont's first employers) in 1924 and Leeds in 1930. York opened on 1 June 1937: 'I acquired premises in York, excellent site, best in York for £25,750' Frederick tells us in his diary. York, of course, featured the famous Belmont Room based on the First Class saloon on the *Queen Mary*, on whose maiden voyage Frederick and his wife Claire had sailed the previous year. The new picture is of the lower floor in Bettys; the older one is the interior of the Cambridge Crescent premises (*see page 55*).

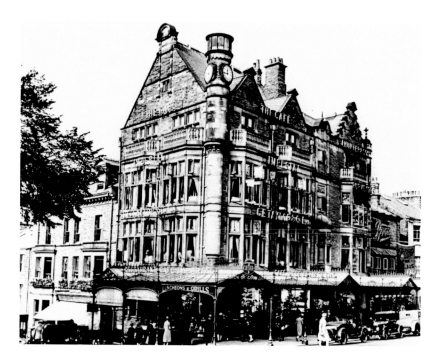

Bettys in Cambridge Crescent

Frederick opened his first business in July 1919 – a café in Cambridge Crescent, on three floors, fitted out to the highest standards, 'furnished in grey, with muted pink panels with old-silver borders [and] candleholders'. The china was grey-blue; the coffee and tea pots heavy nickel silver. Day one takings were £30, with £220 for the first week. In 1920, he opened a second café and takings for the year were £17,000. Customers included Lady Haigh, Lord Jellicoe, the Duke of Athlone and Princess Victoria.

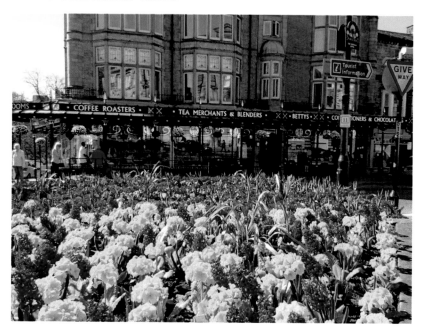

Eat Sweets and Grow Thin

Alleged health benefits were a factor in the expansion of sales of milk chocolate in the early twentieth century, aided by claims of high nutritional values afforded by rich, pure milk content. This, of course, chimed with the traditional claims surrounding so-called medicinal confectionery: lozenges, voice ju-jubes and barley sugar for example all claimed medical benefits, as indeed did Mackintosh's toffee – good for sore throats. Bettys, who produced their own chocolate for sale in their York and Harrogate cafés, tells us that sound German medical research proves that eating chocolate leads to weight loss and is beneficial in the fight against heart disease. Chocolate manufacturers' posters and advertisements of the day were populated with healthy, rubescent children and shapely women.

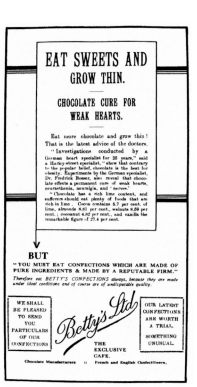

59

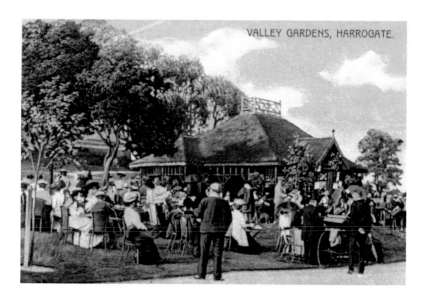

Bettys in the Valley Gardens

A pleasant afternoon taking tea in the Valley Gardens at The Tea House, run by Taylors. Taylors also handled the catering at the Winter Gardens and at the Royal Spa Concert Rooms. Charles Edward Taylor, a Quaker, and son of a York master grocer, set up the business with 'Kiosk' tea and coffee shops in fashionable Harrogate (at 11 Parliament Street) and Ilkley after an apprenticeship at James Ashby, the London tea dealers. His time there had taught him just how crucial the local water was to particular blends of tea – a lesson well learnt and relevant to this day in the form of Taylor's specially blended Yorkshire Tea. The kiosks were followed by Café Imperials in both towns: Ilkley opened in 1896, the Harrogate branch in 1905, in the mock Scottish castle now occupied by Bettys. The Ilkley Bettys is the old Taylors 'Kiosk' Café and Little Bettys in York occupies the former Taylors 'Kiosk' café. In 1962 Bettys acquired Taylors. Their slogan was 'They came to take our waters; they much prefer our tea'.

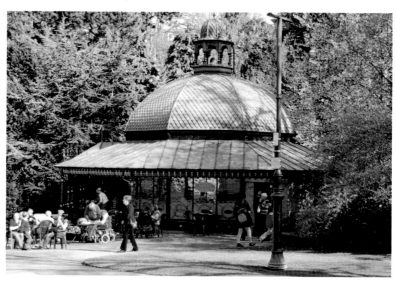

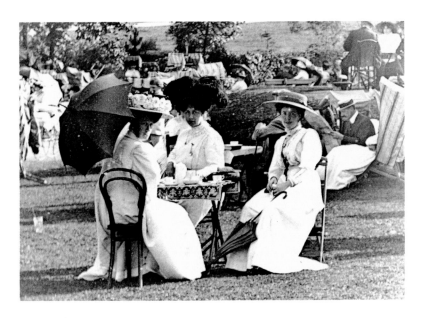

Tea Time ... So Who Really was Betty?

Ladies taking tea at Taylors tea rooms in Valley Gardens. The true identity of Betty has never been revealed and almost certainly never will be. Speculation is rife, however, and there have been many claimants. She may have been the daughter of a doctor who practised next door to the café and who died from tuberculosis; she could have been Betty Lupton, Queen of the Harrogate Wells from 1778 to 1838 and chief 'nymph'; she might also have been the actress Betty Fairfax, who starred in the West End musical *Betty* around 1915 and to whom Frederick took something of a shine; moreover, the musical toured the country and came to Harrogate's Grand Opera House three times between 1916 and 1918. Or, just as plausibly, Betty may be the name of the little girl who brought in a toy teatray during a meeting at which the name for the new café was being discussed ...

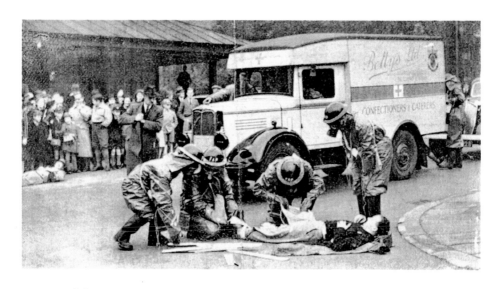

Bettys and the ARP

During the Second World War, Bettys stayed open and, like other cafés and restaurants, proved resourceful in making a little go a long way. Powdered egg, utility flour, corned beef, spaghetti and beans and all manner of scraps were put to good use. On one occasion, Frederick bought a lorry-load of honey, salvaged from a bombed warehouse, and made fudge from it – a rare delicacy in wartime. Occasionally, war brides were unable to cut their cakes as the cake was nothing more than an iced cardboard box. This photograph shows how Bettys transport was pressed into helping the war effort as ambulances once the deliveries were complete.

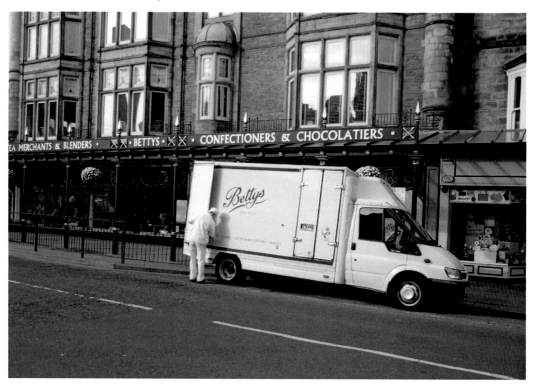

40499. HARROGATE: ON HARLOW MOOR.

Bettys Harlow Carr

The older picture shows Harlow Moor. There used to be a bandstand here that held frequent Pierrot shows. Although the Corporation had bought Harlow Moor in 1898, it could not afford the Carr, so this was bought privately for £8,500 by three councillors in 1914 who thus secured the Gardens for the town. Harlow Carr is the Royal Horticultural Society's 68-acre experimental gardens and features, amongst many other things, the National Collection of Rhubarb. The six imposing Doric columns were salvaged from the Spa Rooms which were demolished in 1939.

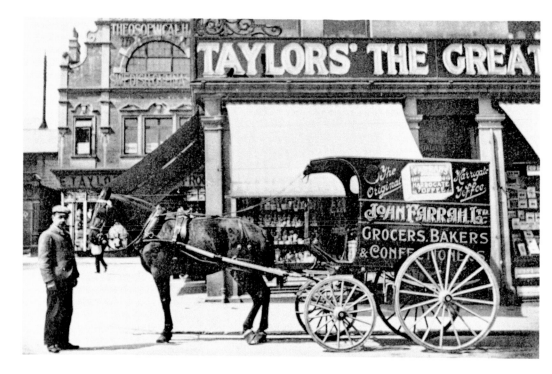

Delivering Farrah's Toffee to Taylors

A delivery of Farrah's toffee to Taylors, the chemist's, in Station Parade in about 1913. The arcade that can be seen in the background housed, among other things, the Theosophical Hall and facilities for Swedish gymnastics. The modern picture is of the interior of Farrah's in Montpellier.

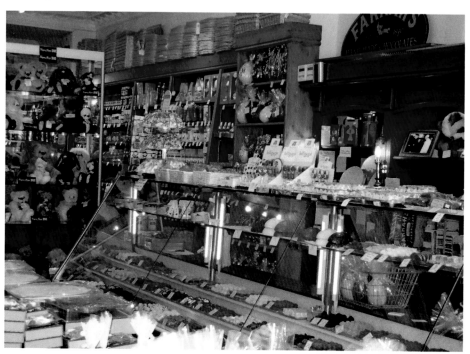

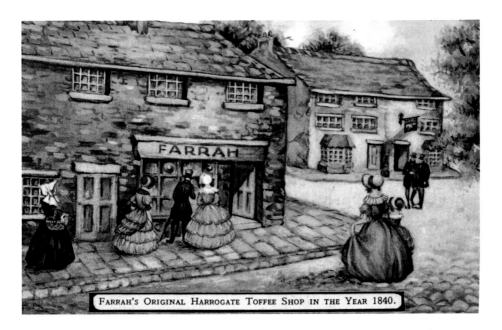

FARRAH'S ORIGINAL HARROGATE TOFFEE SHOP IN THE YEAR 1840.

Farrah's

Founded in 1840 by John Farrah, the shop was originally on Royal Parade but closed in the mid-1990s and now stands on Montpellier Parade. The aim of Original Harrogate Toffee was to cleanse the palate of the putrid taste of Harrogate's sulphur water. Original Harrogate Toffee is similar to both butterscotch and barley sugar and uses three different types of sugar, butter and lemon to give a unique texture and flavour. It is still made in copper pans and packaged in the recognisable trademark blue-and-silver embossed tins.

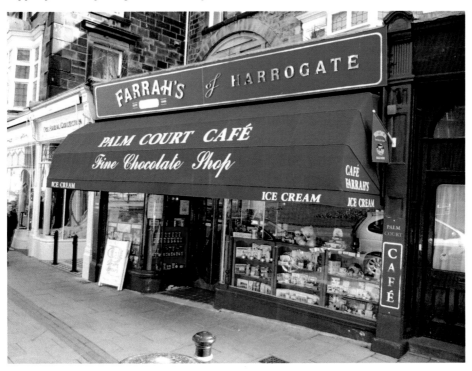

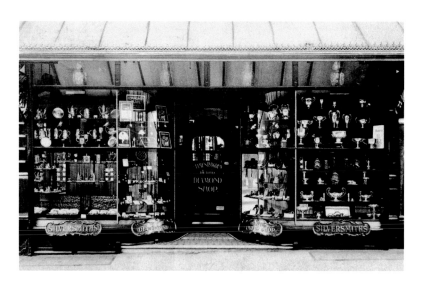

Ogden's and the Tomb of Tutankhamun

In 1893, James Roberts Ogden opened The Little Diamond Shop in Cambridge Street, the genesis of what was to become one of Britain's most famous and prestigious jewellers. The impressive Edwardian shopfront and showrooms in the current James Street shop, bought in 1910, still retain many of the original Edwardian features. Down the years, Ogden's has supplied jewellery and silverware to royalty and heads of state, including Mrs F. D. Roosevelt, King George VI and Princess Marina. Sir Winston Churchill had a silver cigar case made by Ogden's. J. R. Ogden was a celebrated Egyptologist and was adviser to Howard Carter and Sir Leonard Wooley. Carter, of course, went on to discover the Tomb of Tutankhamun in 1922. J. R. Ogden was also Advising Goldsmith to the British Museum, and was involved in the restoration of some of the most precious gold artefacts found in museums around the world. The company is currently run by the fourth and fifth generations of the family.

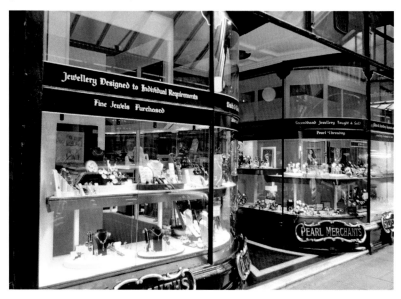

'Uncommonly Famous' Ogden's of Harrogate

Ogden's were frequently called upon to take selections of jewellery to guests in their hotels so they could choose their purchases there. It is this that led to the practice of hotels having jewellery display boxes in their public areas. A 1931 advertisement declares Ogden's to be 'uncommonly famous for rare jewels and pearls' and makes much of its prestigious branch in London's Duke Street. Today's image shows some of the specialist lines stocked in the Harrogate shop.

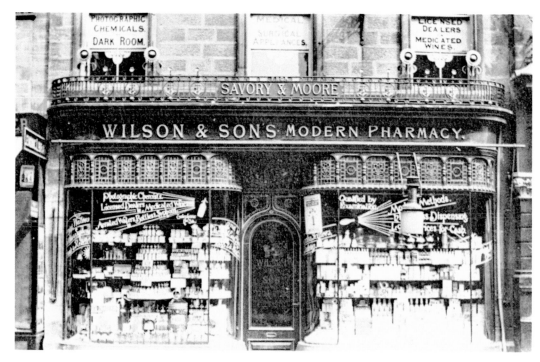

Wilson & Sons at 2 James Street

Wilson's boasted an association with Savory & Moore, New Bond Street, London, chemists to Queen Victoria. This is a most attractive and imaginative window from the early 1900s, when windows were crucial to drawing in custom before the days of in-shop point of sale and self-service. Medicated wines, surgical appliances and photographic services were available. The sunflowers on the balustrade add to the effect. An 1886 advertisement tells us that their service has 'all the accuracy, despatch and elegancy of the best houses in London and Paris'. Wilson & Son had another shop in West Park Stray. In 1928, their premises were bought by Ogden's the jewellers, who already owned the premises next door.

J. Baxter in Havana House

Another magnificent window display, from the early twentieth century, with what could be Mr Baxter standing proudly outside his business, founded in 1868 in Parliament Street. Barling's pipes, Muratti cigarettes and Loewe briar pipes are amongst the items on display. Muratti's was originally a German brand of cigarettes, popular worldwide largely because of the famous commercial created by the legendary Oskar Fischinger – an abstract animator, filmmaker, and painter. Muratti is now part of Phillip Morris Companies Inc. Around the time of the old picture, one of Muratti's brands was 'Young Ladies' Cigarettes'. Both B. Barling & Sons and Loewe were kings amongst pipe makers. Originally eighteenth-century silversmiths, Barling is famous for the fine silver work with which they adorned pipes from 1812; Loewe of Haymarket first introduced briar pipes to English smokers in 1856.

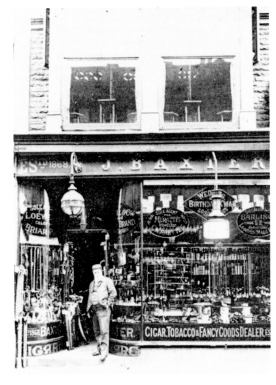

69

Ackrill's

The older picture shows an Ackrill's advertisement from *Thorpe's Illustrated Guide to Harrogate 1886,* featuring a number of local interest books. The modern picture likewise shows a selection of local titles, including some in the *Through Time* series, of which this book is part. Today, Ackrill Newspapers Ltd publishes a stable of papers covering Harrogate, Knaresborough, Nidderdale and Ripon. The first guide to Harrogate was published by bookseller Eli Hargrove in 1875; its publication marked the first of a never-ending succession of such guides providing valuable information on the spa facilities, accommodation and entertainment. Robert Ackrill's Conservative-leaning newspaper, *The Harrogate Herald,* faced competition from the Liberal *Harrogate Advertiser,* launched in 1834 as *Palliser's List of Visitors.*

HARROGATE

A PULLMAN TRAIN

CONSISTING OF

FIRST & THIRD CLASS PULLMAN CARS ONLY

LONDON & NORTH EASTERN RAILWAY

DAILY (SUNDAYS EXCEPTED)

FROM LONDON KING'S CROSS			FROM HARROGATE		
KING'S CROSS	DEP.	11.15 A.M.	HARROGATE	DEP.	11.15 A.M.
LEEDS	ARR.	2.40 P.M.	LEEDS	DEP.	11.45 A.M.
HARROGATE	ARR.	3.15 P.M.	KING'S CROSS	ARR.	3.15 P.M.

CHAPTER 5

A Tour Around Harrogate

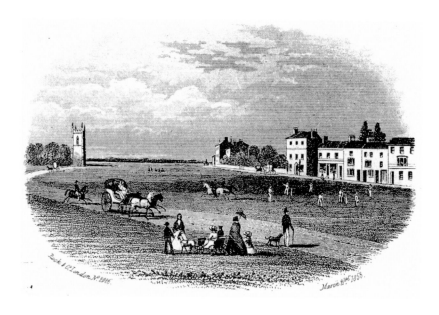

High Harrogate

One of a series of fine prints of Harrogate scenes sold by the bookseller, printer and stationer T. Hollins of 26 Park Parade. The prints were made in 1853 by Rock and Co., London. The 1831 Christ Church (formerly St John's Chapel) is in the background. Before 1800, High Harrogate was Harrogate; Low Harrogate (or Sulphur Wells as it was originally called) was only just beginning to show its potential due to the Old Sulphur Well. But it was to High Harrogate that people initially came, well accommodated by the Granby, Queen and Dragon Hotels. These hotels succeeded boarding houses and, before that, farmsteads where early visitors for the cure stayed – with bath tubs and casks of water from the wells brought in by maids.

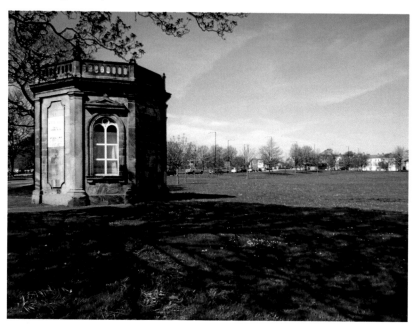

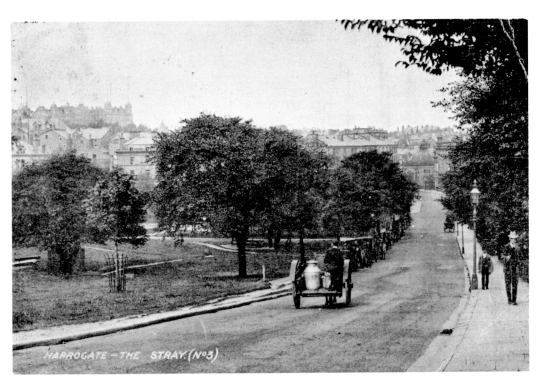

HARROGATE — THE STRAY. (Nº3)

The Stray

The Stray came about after the punitive 1770 Acts of Enclosure with the Duchy of Lancaster Commissioners' great Award of 1778. This ensured that 200 acres of land linking the wells would remain open, thus protecting public access to the springs and allowing space for people to exercise in – exercise was just as important a factor in the cure as the waters. In addition, the land was used for concerts and accommodated a racecourse for a while from 1793. Eli Hargrove opened a subscription library nearby in around 1775. For Queen Victoria's Jubilee in 1887 a huge barbecue was held on the Stray; the people of Harrogate roasted an ox for twenty-four hours, ate 4,000 buns and drank 500 gallons of beer. During the war, trenches were dug to prevent enemy planes from landing there.

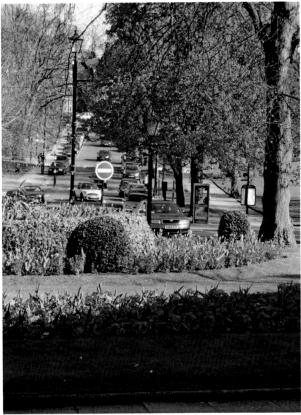

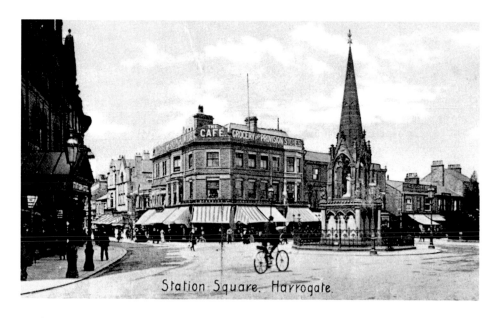

Station Square. Harrogate.

Station Square and the Barren Cows

Much of this was demolished to make way for the Victoria Gardens Centre. The Queen Victoria Jubilee Monument was erected in 1887, by Mayor Richard Ellis, to mark Victoria's Golden Jubilee. This was all part of the Victoria Park Company scheme to develop a new town centre linking the two Harrogates with residential and retail streets. The railway arrived in Harrogate in 1848 and the new station opened in 1862, bringing trainloads of tourists and thus heralding the start of Harrogate's tourist industry. Not everyone was enthusiastic though: it was thought by some that the trains would bring the 'lower orders' to the town and reduce the milk yield from local cows.

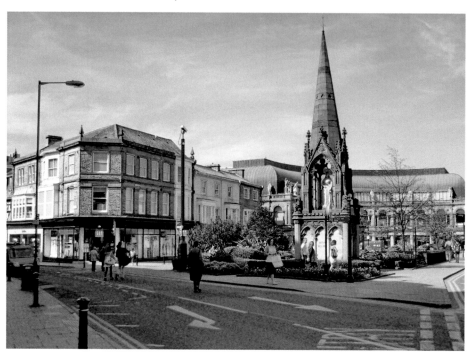

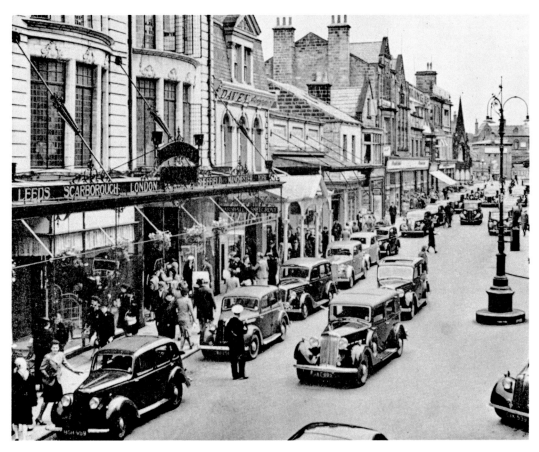

James Street

At the turn of the twentieth century, James Street was paved with wooden blocks to reduce traffic (mainly horse-driven) noise. The superb building with the white tiling was Marshall & Snellgrove. Traffic remains a problem.

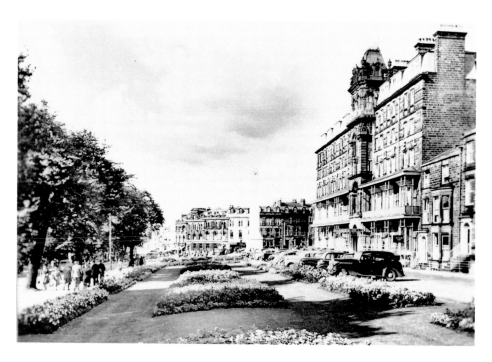

Prospect Place and the Prospect Hotel

Originally a private house, built in 1814 by Nicholas Carter Snr, it gradually developed into a hotel as the owner took on more and more guests during the season. After a series of reconstructions, the hotel, then named the Prospect, had doubled in size by 1870 and sported its 82-foot tower. The fine ironwork on the façade was removed in 1936. Today it is the Yorkshire Hotel.

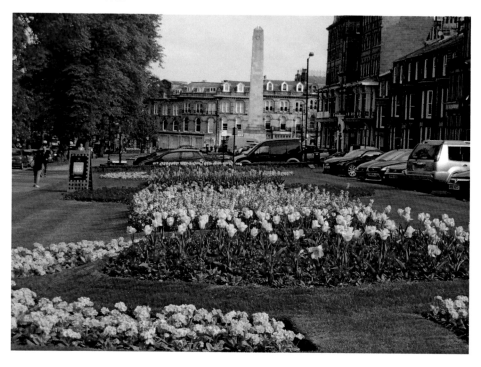

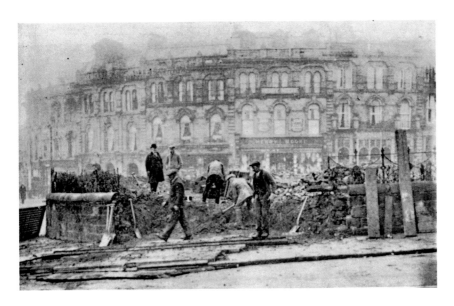

Demolishing Prospect Gardens

The First World War had a number of effects on the town. Those accustomed to visiting spas on the Continent came to spas like Harrogate instead. Foreign dignitaries in exile sometimes sought refuge in Britain; one such was the Grand Duchess George of Russia, daughter of King George I of the Hellenes. She had married Grand Duke George Mikhailovitch, cousin of Tsar Nicholas II, who was murdered by the Bolsheviks in 1919. She set up a small hospital in Tewit Well Road to help care for the war-wounded and recuperating soldiers and, in 1920, erected a memorial to the soldiers who died in her hospital. Princess Alix of Hesse visited in 1894, granddaughter of Victoria and future wife of Tsar Nicholas II. The old picture shows the gardens being demolished to make way for the Cenotaph, which still remains a focal point of the town as this charity event in 2011 shows.

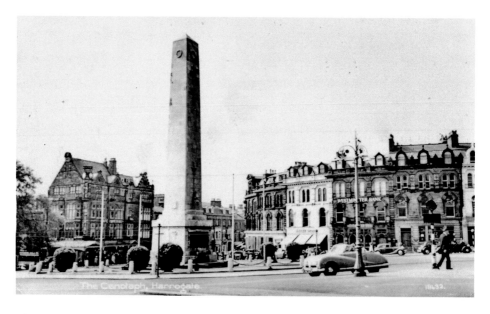

The Cenotaph

Princess Mary and Viscount Lascelles did the honours on a rainy day, 1 September 1923, when they unveiled the war memorial. The noble obelisk that is the Cenotaph dominates Prospect Place. Nearly 800 dead or missing are remembered. In nearby Tower Street, R. W. Slee ran his Practical Bicycle and Tricycle Fitter business. He also specialised in the repair and 're-India-Rubber tiring' of Bath Chairs, as well as knife cleaning and wringing-machine repairs.

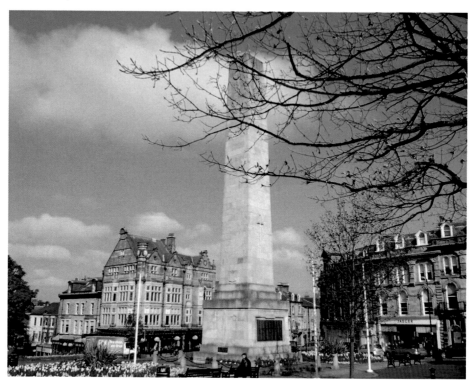

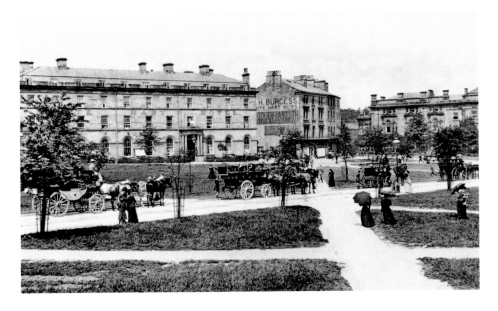

White Hart Mews and the Charabancs

Burgess' Livery Stables provided the service here. Another carriage company was Mackay & Fowler Carriage Manufactory, who were prominent at the end of the nineteenth century and specialised in landaus fitted with Patent Automatic Head. After the First World War, Harrogate witnessed a significant change in its clientele. The exclusive, aristocratic visitors of the pre-war period gave way to what was dismissively called the 'charabanc trade' – obviously not as wealthy but well enough heeled all the same. To cater for this new market, the Valley Gardens were developed with the Sun Colonnade and Pavilion, and the Royal Baths were extended.

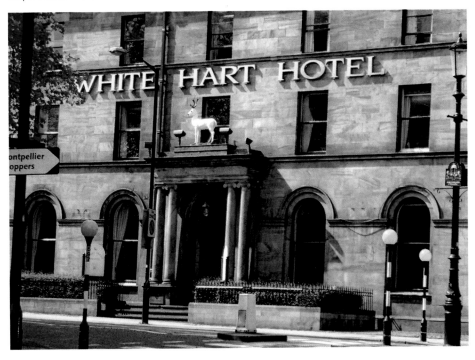

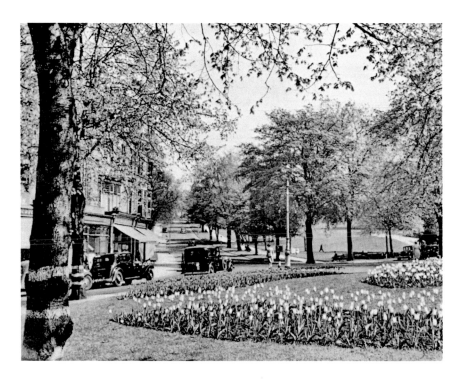

Montpellier Parade

Much of this was built in the 1860s, by Harrogate builder George Dawson, adjacent to Thackwray's Montpellier gardens of the same name. Thackwray tried to divert the waters of the Old Sulphur Well to the back yard of the Crown by sinking a well there. This led to an Act of Parliament giving Harrogate powers to protect their mineral waters against such piracy.

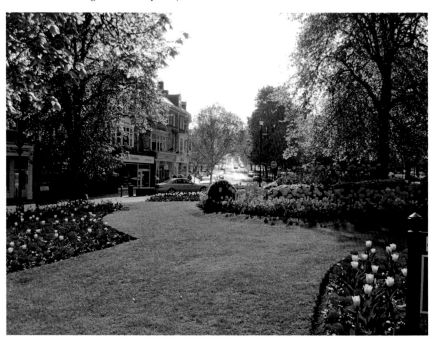

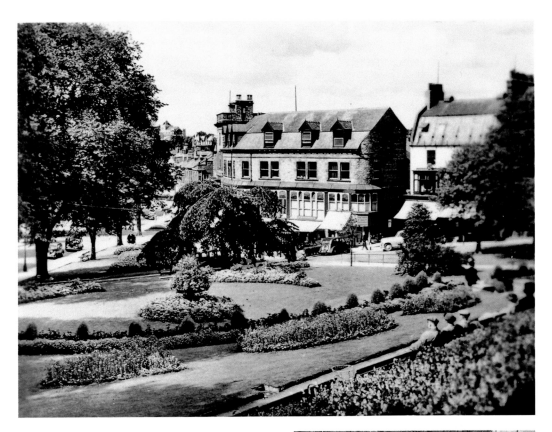

Montpellier Gardens

Laid out by Joseph Thackwray, the gardens became increasingly popular when the Montpellier Baths were built in 1834. They were, however, much diminished by the construction of the Royal Baths, and the Montpellier Baths themselves were then demolished in 1895. The octagonal stone building, which was the gatehouse to the Montpellier estate, survives (*see page 23*) but the pump room from 1874 was demolished in 1954. An extension to the Royal Baths was built in 1911 to house the Plombieres Baths, specialising in the treatment of muco-colitis and other gastrointestinal disorders, as championed by Sir Frederic Treves, Serjeant Surgeon to Edward VII. Treves carried out the first successful appendectomy in England in 1888 (until then appendicitis carried a high mortality rate) and it was he who befriended Joseph Merrick, the Elephant Man, in the London Hospital for four years. With tragic irony, Treves died of peritonitis; Thomas Hardy, a close friend, composed a poem in his honour and recited it at his funeral.

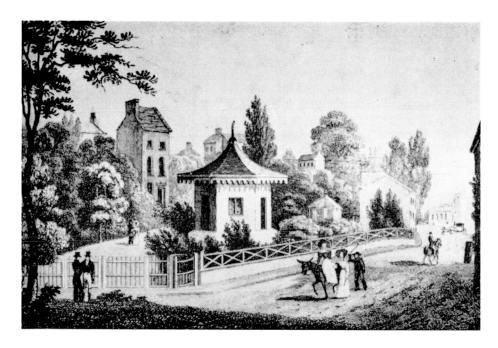

The Chinese Temple

Thackwray built a small, hexagonal pump room in the form of this beautiful Chinese temple, which became known as the Montpellier Pump Room in 1822 for the Strong Montpellier, or Crown Spring. Electrotherapy, as we have seen (*page 16*) was all the rage and one of the chief suppliers in the 1880s was the Electropathic Establishment in Volta House, Station Parade, later moving to Chapel Street. Mr W. Hardy, consulting electrician, was assisted there by his niece Miss Burras and specialised in electric, magnetic and hydropathic belts, bands and batteries.

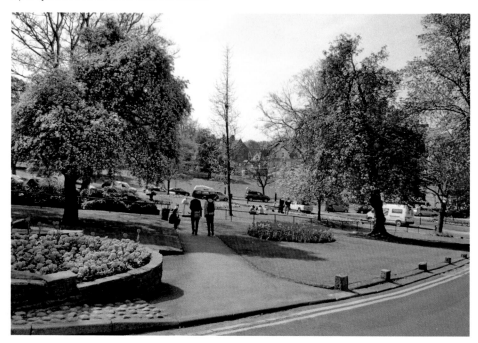

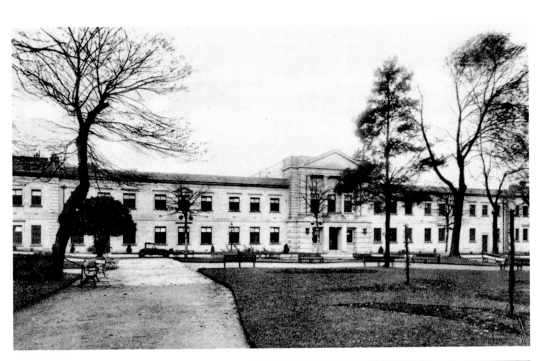

Municipal Buildings and Cupid & Psyche
Converted in 1931 from the Victoria Baths, which were built in 1871 by the Improvement Commissioners. It was around here and in Crescent Gardens that the morning promenade took place from about 6.30 a.m. Smart dress was essential, as was propriety of the first order. The pavements were washed down twice a day – the first before 7.00 a.m. partly to ensure that ladies' long dresses did not get covered in dust. The modern photograph shows the beautiful statue of Cupid and Psyche, carved by Giavanni Benzoni for the Spa Rooms Gardens around 1870. When these gardens were dug up in 1958, the statue was placed in storage and forgotten about until a chance rediscovery some thirty years later.

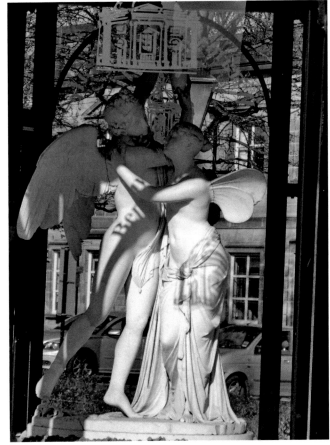

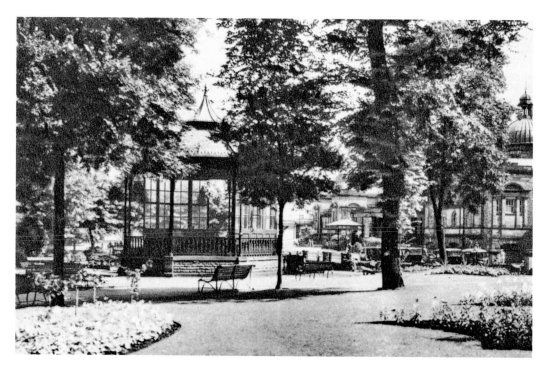

Crescent Gardens

Originally laid out in 1890, on the site of the Crescent Inn, this was known as the Globe in the early eighteenth century and then the Half Moon around 1783 when the sulphur springs were discovered. The modern photograph shows that elegance – and millinery – lives on in Harrogate in this shot taken in nearby Prospect Gardens.

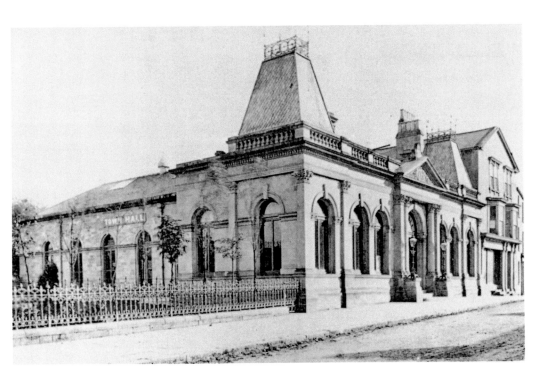

The Promenade Room and Alice Frith's Birthday

In Swan Road the Promenade, or Victoria Room, a kind of Assembly Rooms, to some extent marked the rise of Low Harrogate over High Harrogate. The presence of sulphur springs, as well as iron springs, in the lower part of town fuelled its popularity and the 1806 construction of the Promenade Room – where visitors could read the papers, listen to music, play cards, converse and attend balls, all for 12s a year – signified its status as *the* place in Harrogate to be. Unfortunately, it did not catch on, and in 1874 became the Town Hall Theatre (Lilly Langtry and Oscar Wilde performed here), from 1912 to 1921 the Mechano-Therapeutic Department of the Royal Baths, and then the Old Town Hall. The Mercer Art Gallery now occupies the site and includes works by Turner, Atkinson Grimshaw, Arthur Rackham and William Powell Frith. Frith was born in Aldfield, near Ripon, in 1819 and is considered to be one of the most influential artists of the Victorian age. His best-known works are *Life at the Seaside*, *Derby Day* and *The Railway Station*, and the famous *Many Happy Returns of the Day, 1856* – a depiction of Frith's own family at his daughter Alice's sixth birthday. His private life was as hectic and colourful as his art, with a wife and a mistress producing nineteen children. He was a close friend of Charles Dickens, whose novels inspired many of Frith's paintings.

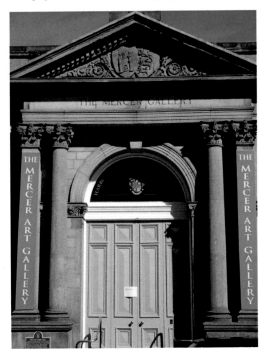

In the Valley Gardens
Harrogate

A.R.Q

Valley Gardens

Thirty-six springs rise within one acre of the Valley Gardens (there are eighty-nine in the town as a whole and each one is chemically different) all pumped down to the Royal Baths. The gardens were enlarged in 1901 to what is more or less their current layout. The central part was originally called Bog Fields after the boggy area that used to be there. The metal covers with their unique numbers, indicating the presence of a spring or well beneath, have long been removed in the interests of the efficiencies required for grass cutting.

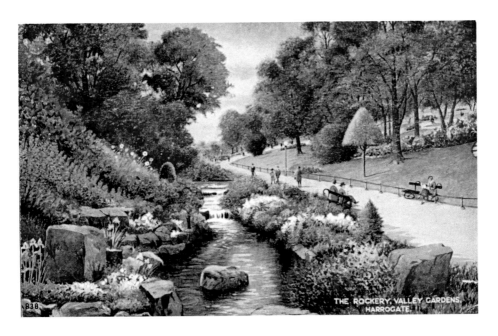

The Rockery, Valley Gardens

The main pathway through the gardens to the Magnesia Well is Elgar Walk and commemorates the many visits Edward Elgar made to the town. On the other side of the gardens is the Sun Colonnade, visible in the background of the modern picture, which leads to the Sun Pavilion. Originally opened in 1933, it was refurbished in 1998 and reopened by Queen Elizabeth II.

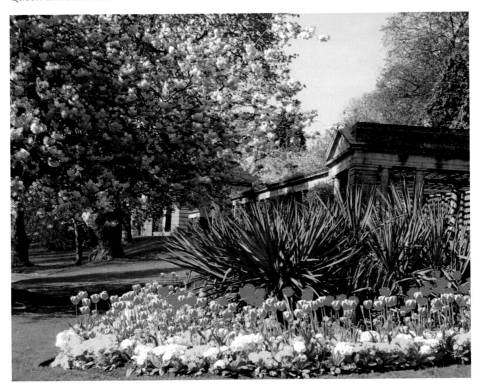

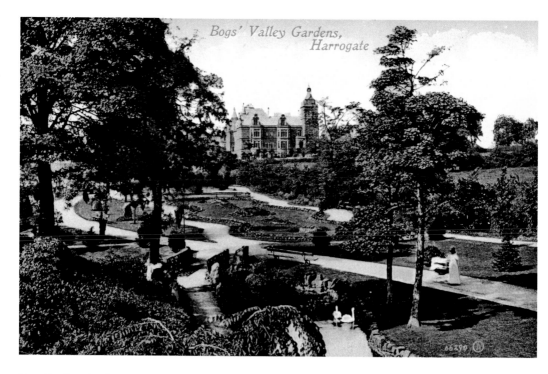

Bogs' Valley Gardens,
Harrogate

Bogs' Valley Gardens

The Royal Bath Hospital can be seen in the background of the older photograph. The new one, looking in the opposite direction, shows the board that describes the chemical constituents of the springs.

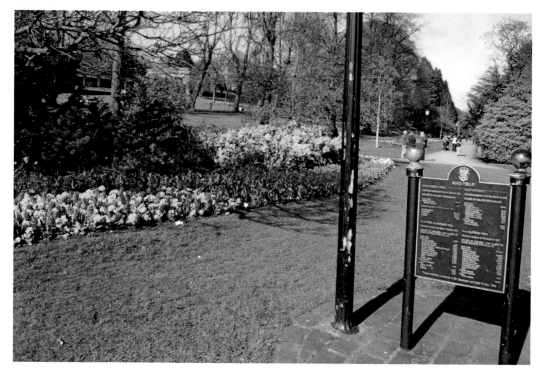

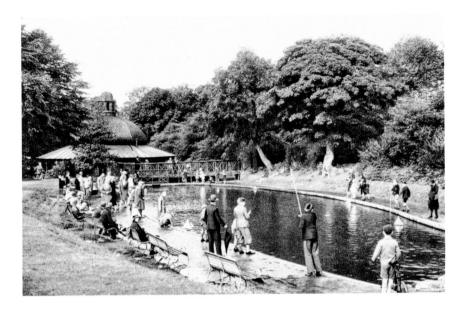

The Boating Lake

Still very popular – despite the lone craft traversing the lake today – the boating lake is a scene that has changed very little over the intervening seventy years. Until the beginning of the nineteenth century, Harrogate was smaller than Knaresborough; at the end of the 1690s it had 57 houses to Knaresborough's 156. Harrogate does not appear in *Domesday* and we have to wait until 1332 before the first reference, as part of the roll for Knaresborough Court. The name comes from the Norse *Here gatte*, the road to Harlow, or to Haverah, which in turn means the road to the soldier's hill. Haverah was a royal park dating back to 1100. After the mineral springs were discovered and popularised, the population exploded and was at 1,500 by 1810.

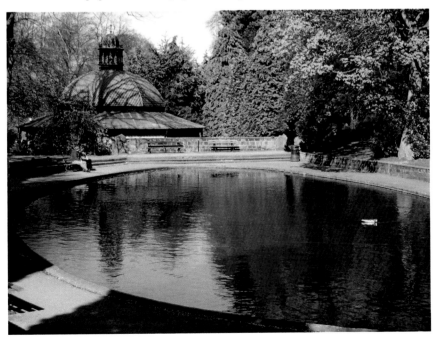

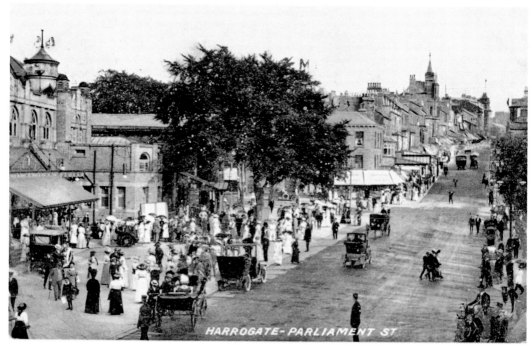

HARROGATE - PARLIAMENT ST

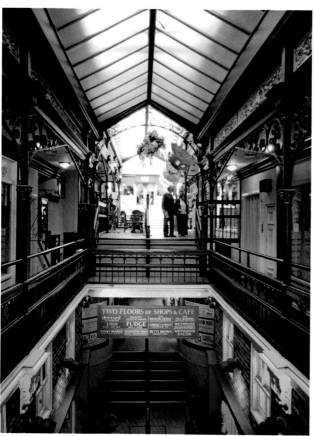

Parliament Street

Parliament Street was the first street in Britain to be lit by water gas, supplied from the Water-Gas Plant that stood on the site of the Winter Gardens – established by Samson Fox (1838–1903), Mayor of Harrogate, provider of ox roastings, and inventor. People came from all over Britain to see how 'the Mayor of Harrogate has bottled the sun'. The plant was demolished in 1897 to make way for the Winter Gardens. Fox also invented the corrugated boiler flue and the pressed steel railway bogey, and helped finance the Royal College of Music in London near to the Royal Albert Hall. Almost opposite the Winter Gardens is the 1898 Westminster Arcade with its Gothic towers and two floors of elegant shops, as can be seen in the new photograph.

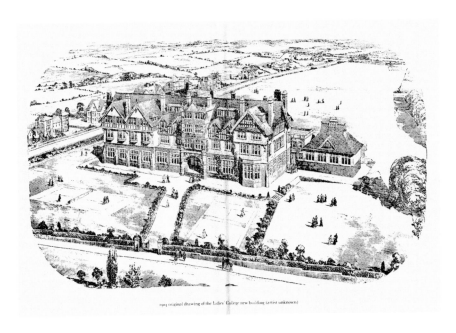

1904 original drawing of the Ladies' College new building (artist unknown)

Harrogate College ... for Boys

The original Harrogate College was a boys' school, on Ripon Road, founded in the 1880s. As was the norm, discipline was taken very seriously. Some extracts from the 1893 *Rules for the Boys' College* are very instructive: Free conversation is allowed in the dining room, but not loud talking or laughter. Reading while eating is forbidden. On leaving the room, pupils are expected to bow to the master on duty ... On Sundays no playing or reading unsuitable books is allowed. No talking is allowed going to and from church. All must keep step ... the fine for letting soap, flannel etc. choke the bath waste pipe 3*d*; fine for throwing paper on the floor ½*d*; fine for losing the copy of the rules 2*d*. The older picture shows the college in 1904.

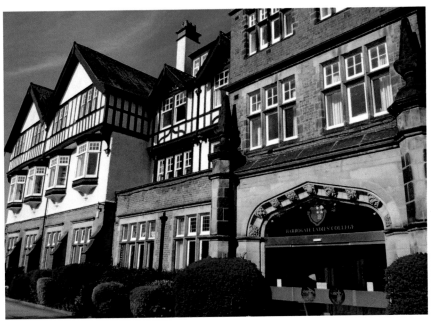

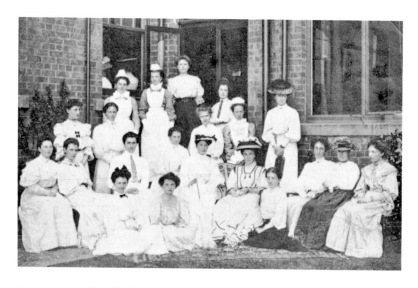

Harrogate Ladies' College

Around the same time, there was obvious demand for the boys' sisters and other girls and so Mr G. M. Savery, head of the college, opened a small school in Dirton Lodge, Ripon Road, in 1893. Tuition fees were £6 per term. The boys' school did not survive and in 1904 the ladies' college moved to the present purpose-built accommodation on the Duchy of Lancaster Estate for eighty boarders and forty day girls. Even in those early days, ergonomics was important; L. Ruggles Roberts, writing in the *Girl's Realm* in 1904, tells us, 'Here all is charming ... [the desks] are known as Dr Roth's hygienic desks and contain a pad for the support of the pupil's back which may be adjusted to any height ... the desk too may be lifted up or down ... which all prevents the pupil from stooping and becoming round shouldered.' 'Free Lance' in the *Harrogate Advertiser* adds: 'The rooms are ventilated by air shafts communicating with Boyle's patent Air Pump Ventilators on the roof.' The Head in the older photograph was Miss Jones; the new picture shows today's Head, Mrs Rhiannon Wilkinson, with students.

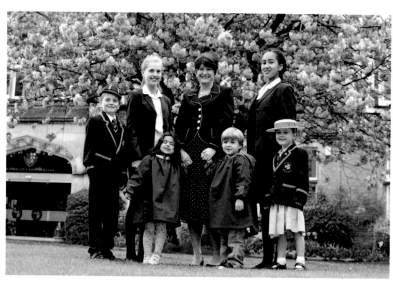

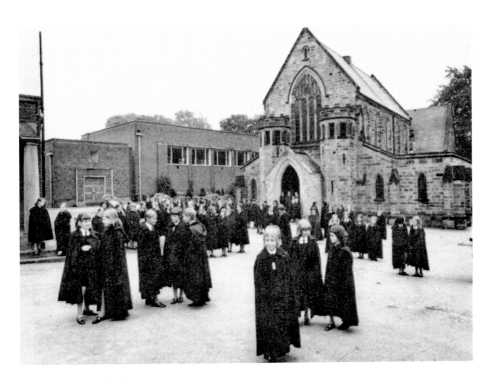

The Choir at York Minster

Two to four hours daily were spent in the open air. The gym mistress was trained by Madam Bergman Osterberg and games included cricket, hockey, vigoro and basketball. The uniform comprised a green coat and skirt, white blouse and white sailor hat. The chapel was built in 1924 – the first St Mary's church in Low Harrogate had been dismantled because of subsidence. During the Second World War, the school was requisitioned by the MOD and the staff and girls decamped to Swinton Castle, Masham. The new photograph shows the college choir at a recent performance in York Minster.

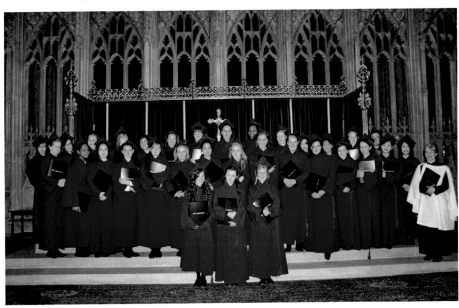

Great Yorkshire Show, 1929

Before 1951, when Harrogate became the official home, the Great Yorkshire Show was held in a different town every year. Now, the three-day event attracts over 100,000 visitors onto its 350-acre site and becomes the temporary home for 8,000 animals, including 1,000 horses and ponies. Over 900 stalls and stands offer every kind of product and service imaginable. The modern shot shows the Cock o' the North Championship at the 2010 Show. About 2,000 horses and ponies competed over three days, on a course created by Bob Ellis. Prize money totalled £40,820. The famous Silver Cockerel Trophy was presented to the Yorkshire Agricultural Society by the jeweller's, James R. Ogden & Sons Limited; it was first competed for in 1968 – the winner was David Broome riding A. Massarella & Sons' 'Mister Softee'.

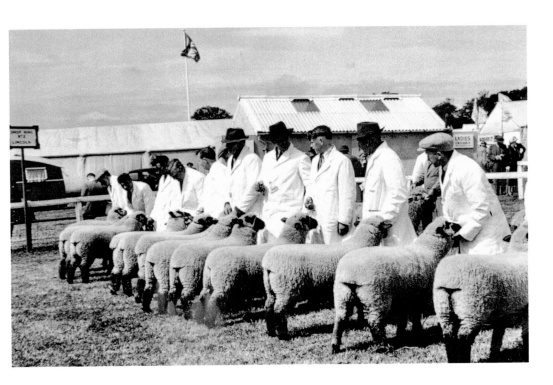

Sheep Show

If nothing else, these photographs show that, on the surface at least, sheep judging changes little down the years at the Great Yorkshire Show. The only significant difference here is the involvement of women in more recent years. Overall, competition classes ranged across twenty-four different sections with 12,000 entrants, from driving four-in-hand coaches, to classes for honey, poultry, showjumping and the cattle, sheep and pigs.

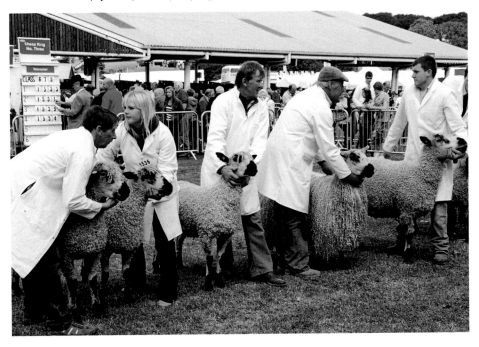

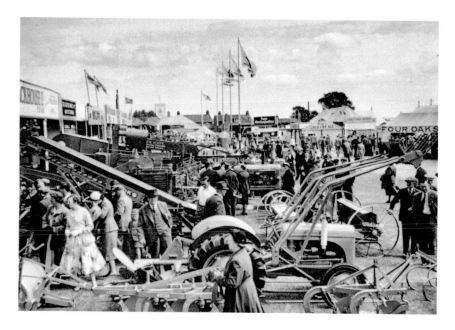

Supreme Beef

A splendid shot of tractors and other farm machinery at a 1950s show matched with the champion Supreme Beef from 2010. The Great Yorkshire Show came to be in October 1837 when a group of leading agriculturalists, led by the third Earl Spencer, met at the Black Swan Hotel in Coney Street, York, to discuss the future of the farming industry. The result was the inauguration of the Yorkshire Agricultural Society, whose aims were to improve and develop agriculture and to hold a prestigious annual show. The first Yorkshire Show was held in Fulford, York, in 1838. The first recorded attendance figures were in 1842, when the Show was again held in York, attracting 6,044 visitors.

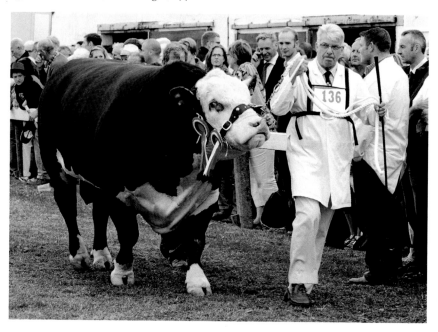